IMAGES
of America

POCATELLO IN PRINT
FROM THE ARCHIVES OF
THE *IDAHO STATE JOURNAL*

IMAGES
of America

POCATELLO IN PRINT
FROM THE ARCHIVES OF
THE IDAHO STATE JOURNAL

Students from Idaho State University's
MGT 4499/5599 Class

Thad Curtis, Shelby Fitzgerald, Daniel Heithoff,
Mary Hill, Kim Jeffery, and Rebekah Punt

ARCADIA
PUBLISHING

Published by Arcadia Publishing
Charleston, South Carolina

Printed in the United States of America

Library of Congress Control Number: 2018932488

For all general information, please contact Arcadia Publishing:
Telephone 843-853-2070
Fax 843-853-0044
E-mail sales@arcadiapublishing.com
For customer service and orders:
Toll-Free 1-888-313-2665

Visit us on the Internet at www.arcadiapublishing.com

This book is dedicated to the citizens of Pocatello, whose daily contributions have shaped this community and positively affected the lives of the next generation.

CONTENTS

Acknowledgments

We wish to thank Ian Fennell and the *Idaho State Journal* (*ISJ*) for their sponsorship of this project, with special thanks to Jenny Hopkins for her assistance in locating photographs and early editions of the *Pocatello Tribune* (the *Journal's* predecessor). We also wish to thank Lynn Murdoch with the Bannock County Historical Museum and Trent Clegg with Pocatello's Marshall Public Library for their generous research assistance and allowing us to use *ISJ* photographs stored in their collection.

Thanks to Ron and Patty Bolinger, whose generous financial gift to Idaho State University (ISU) provided the funding for this project, and for their extensive editorial assistance. Thanks to Brooke Barber for her invaluable support, photographic eye, and editorial assistance. Thanks to Kathy Albano for guidance from her research on the history of aviation in Pocatello. Thanks also to Dean Tom Ottaway and the faculty, staff, and administration of ISU's College of Business for their encouragement and great ideas. Many thanks to Dr. Cindy Hill of ISU's Student Success Center and Dr. Sherri Dienstfrey-Swanson and Dr. Jamie Romine-Gabardi of the University Honors Program for allowing us to offer and promote this class as a University Honors Program course. Special thanks go out to our title editor, Stacia Bannerman, and the staff and administrators at Arcadia Publishing for their help and support. To those not named here who supported this project in ways big and small, direct and indirect, we thank you—this book would not have been possible without you.

INTRODUCTION

This book is unique in that it was written by a group of six students, selected through a competitive application process, over the course of a 16-week semester. The class, a collaboration between Idaho State University's College of Business and University Honors Program, focuses on teaching collaborative creativity—that is, how to coordinate a long-term, intensive creative project with a tangible output that provides a valuable product to their community.

This book is also unique because it explores the stories of Pocatello from the perspective (and through the camera lens) of the *Idaho State Journal* and its predecessor in Pocatello, the *Pocatello Tribune.* Early in the book-writing process, the student coauthors in this class came up with a creative structure for presenting these stories—the book is organized into chapters that roughly approximate the sections of a newspaper. Chapter one provides a prologue with background information on the *ISJ* and *Pocatello Tribune* and their role in telling the stories of Pocatello. Chapter two provides glimpses of the evolution of Pocatello, with photographs of buildings and industries that shaped Pocatello's early history. Chapter three profiles noteworthy individuals from early in Pocatello's history who achieved acclaim in Pocatello or elsewhere but whose stories have since been largely overlooked or forgotten. Chapter four highlights sports teams, leisure activities, rodeos, the arts, and the range of theaters that once entertained the many visitors who came through Pocatello on the Oregon Short Line or Union Pacific Railroads. Chapter five focuses on the photographs and headlines of wartime in Pocatello. From World Wars I and II to the Korean and Vietnam Wars and more contemporary conflicts, this chapter illustrates how conflicts a world away have an indelible impact on families and local life. Chapter six turns the lens back to the newspaper and provides an intriguing, sometimes whimsical sampling of nearly a century of advertisements in Pocatello's newspapers. Chapter seven wraps up the book by exploring where the past meets the present in Pocatello.

Of course, no single book could do justice to every aspect of Pocatello's history. The purpose of this book is to transport the reader back in time to sample what Pocatello looked like in a different era, how its citizens lived, how it has changed in many ways, how it has remained the same in others, and how its people have endured through eras of growth and stagnation, good weather and bad, and through times of war and peace, all through the lens of the *ISJ.*

Unless otherwise noted, all photographs are courtesy of the photo archives physically located at the *ISJ* building in Pocatello or the *ISJ*'s digital archives. We also collected archived *ISJ* photographs from the Bannock County Historical Museum (BCHM), the Marshall Public Library (MPL), and Idaho State University (ISU). We hope you enjoy *Pocatello in Print: From the Archives of the Idaho State Journal.*

—Alex Bolinger
Associate Professor of Management
Idaho State University, Pocatello

One

Prologue

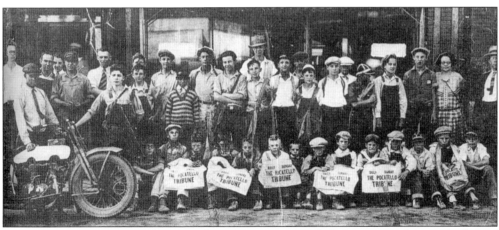

Pocatello's first newspaper, the *Pocatello Tribune*, was founded in 1890. In these early days of newspapers, most were published on a weekly or semiweekly basis. In 1901, the *Tribune* was a semiweekly paper published on Wednesday and Saturday mornings. For about a penny per issue, Pocatellans could keep up on world events as well as local happenings.

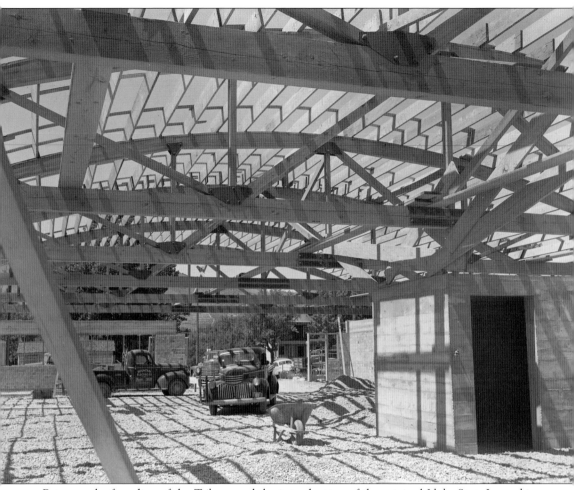

Between the founding of the *Tribune* and the introduction of the original *Idaho State Journal* in 1924, several other newspapers came and went. None of them were able to last in the competitive environment. In 1932, the *Idaho State Journal* was sold to the *Pocatello Tribune*. Both papers coexisted for a time, as the *Tribune* was delivered in the afternoon and the *Journal* published as a morning edition. This continued until a shortage of newsprint caused by World War II occurred in 1942. The shortage meant that only one paper could be printed, and the *Idaho State Journal* was suspended until 1949. After that, the *Tribune* was reintroduced as a new *Idaho State Journal*, and the newspaper moved to the current location at 305 South Arthur Avenue in 1951. This photograph shows an early phase of construction on the new building.

The Ifft family was very influential in the newspaper business in Pocatello. George Nicholas Ifft and his partners, William Wallin and C.H. Fernsternmaker, purchased the *Tribune* in 1892. Prior to the purchase, a fire had destroyed the original frame building at Center Street and Second Avenue. The paper was restored by a pair of men from Montpelier by the names of Eldredge and Hardy, but they were only involved for a few months before Ifft and his partners took over. Later, the senior Ifft turned the paper over to his son George N. Ifft II (shown below attending a chamber of commerce meeting). He was active in production of the newspaper until his death in 1974. His son, known as Nick Ifft III (right), a Princeton graduate and civic leader, maintained the *Idaho State Journal* legacy throughout his life as well. (Both, courtesy of BCHM.)

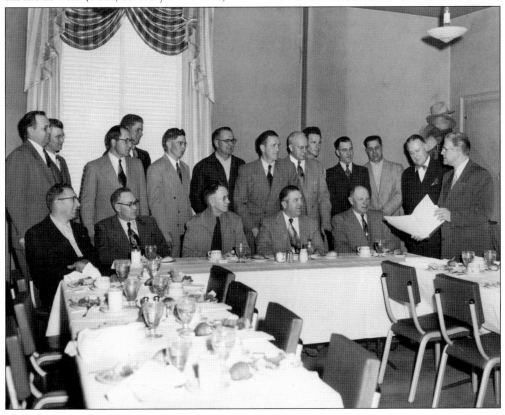

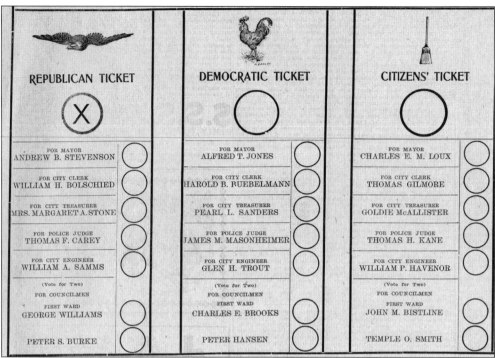

REPUBLICAN TICKET	DEMOCRATIC TICKET	CITIZENS' TICKET
(X)	()	()
FOR MAYOR ANDREW B. STEVENSON	FOR MAYOR ALFRED T. JONES	FOR MAYOR CHARLES E. M. LOUX
FOR CITY CLERK WILLIAM H. BOLSCHIED	FOR CITY CLERK HAROLD B. RUEBELMANN	FOR CITY CLERK THOMAS GILMORE
FOR CITY TREASURER MRS. MARGARET A. STONE	FOR CITY TREASURER PEARL L. SANDERS	FOR CITY TREASURER GOLDIE McALLISTER
FOR POLICE JUDGE THOMAS F. CAREY	FOR POLICE JUDGE JAMES M. MASONHEIMER	FOR POLICE JUDGE THOMAS H. KANE
FOR CITY ENGINEER WILLIAM A. SAMMS	FOR CITY ENGINEER GLEN H. TROUT	FOR CITY ENGINEER WILLIAM P. HAVENOR
(Vote for Two) FOR COUNCILMEN FIRST WARD GEORGE WILLIAMS	(Vote for Two) FOR COUNCILMEN FIRST WARD CHARLES E. BROOKS	(Vote for Two) FOR COUNCILMEN FIRST WARD JOHN M. BISTLINE
PETER S. BURKE	PETER HANSEN	TEMPLE O. SMITH

The Ifft family was also known for being staunchly Republican in a town that leaned Democratic at the time. The railroad was strongly influential, and unions held sway. This local election ballot from 1907 was published in the *Tribune*. It took the liberty of suggesting that the proper thing to do would be to vote Republican. The winner of the mayoral race that year was Dr. C.E.M. Loux, of the lumber firm of Loux, McConnell & Co. He was previously a member of the city council and represented the "Citizens' Ticket." The image below, although from a later era, shows the citizens of Pocatello coming together to vote for their preferred candidate. It was taken in 1950 at the Pocatello Courthouse.

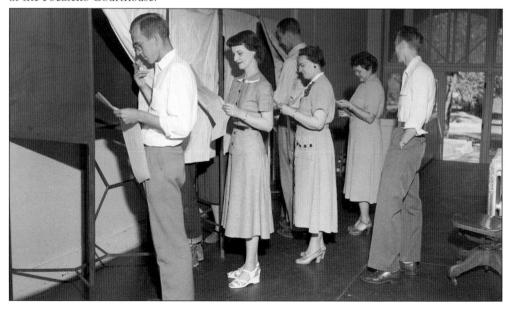

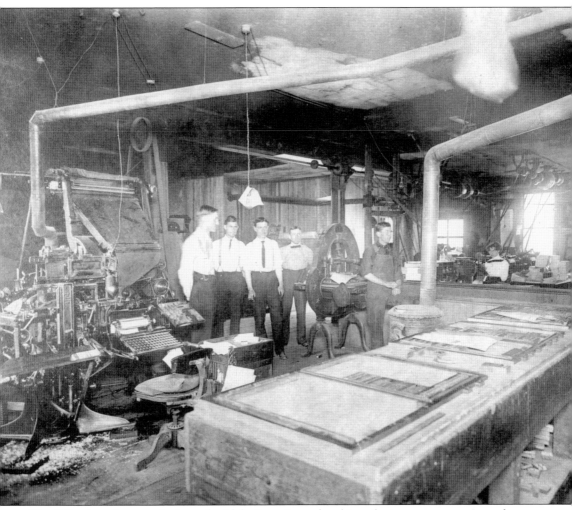

The following photographs from the *Idaho State Journal* archives depict press room scenes from the *Pocatello Tribune* and *Idaho State Journal*. These photographs illustrate some of the advances in printing press technology that took place through the 1900s. First introduced by Gutenberg in the 1400s, early presses used trays of movable type. Some of these trays are pictured here in the foreground.

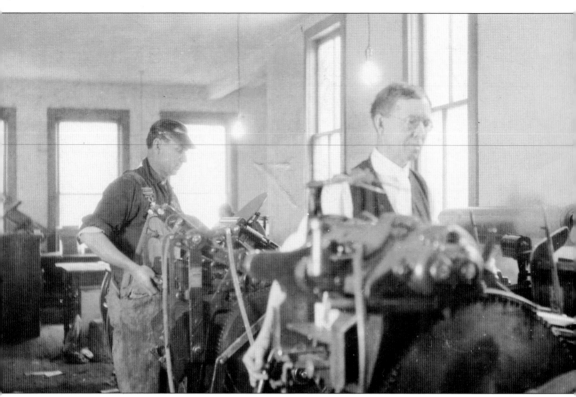

This 1907 photograph from the *Pocatello Tribune* shows the pressman hard at work. He appears to be operating a machine known as a letterpress. Letterpress is a form of relief printing in which the image to be printed is higher than the background, or "in relief." Type is inked with a roller and pressed into the paper.

POCATELLO ELKS HOME WILL BE AN ARCHITECTURAL MASTERPIECE

A 1907 edition of the *Pocatello Tribune* included this rendering of the proposed Elks lodge in Pocatello. The order was founded to promote the virtues of "Charity, Justice, Brotherly Love and Fidelity." Pocatello's chapter of the Elks was founded in 1901 and was only the fourth in the state. During this period, it was uncommon for images to appear in newspapers, due to limitations of the printing process. Early newspapers did not have the ability to recreate photographs but instead used etchings or engravings. Wood engravings were common because they could be printed at the same time as type. American newspapers did not feature photographs routinely until 1919. This was around the same time an equipment revolution occurred, bringing forth lighter cameras and faster shutters, which greatly increased the prevalence of photographs in general.

15

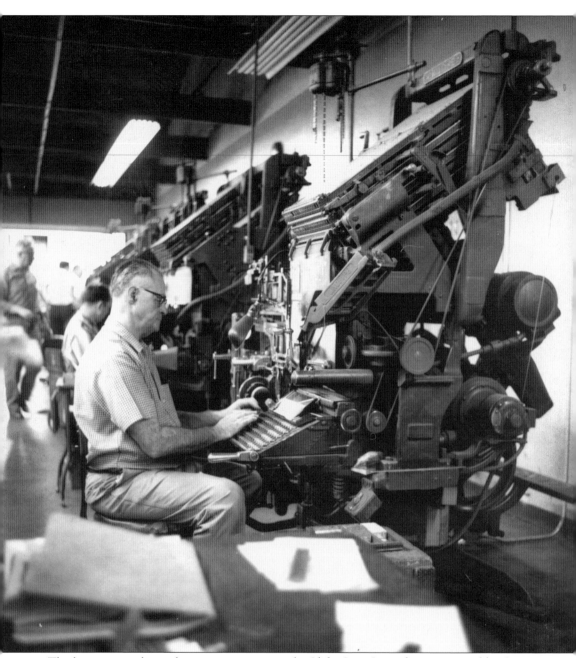

The linotype machine, shown in operation at the *Idaho State Journal*, was invented by Ottmar Merganthaler in 1884. This invention revolutionized newspaper printing at the time, allowing typesetters to cast entire lines of type rather than individual characters. It quickly became the main method used to set type, especially for newspapers and magazines. Prior to this method, the typesetting process was so labor intensive and time consuming that daily newspapers were limited to a maximum of eight pages.

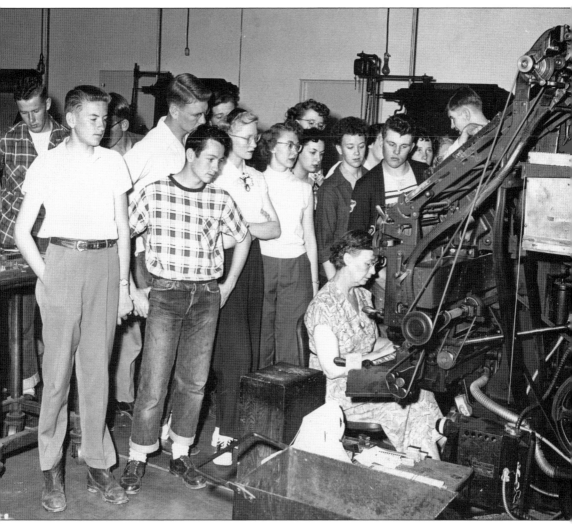

Here, students visit the *Idaho State Journal* during a field trip. They are watching a typesetter as she manually sets text for printing in the newspaper. The type was set using the 90-character keyboard of the linotype. This method remained in use until the 1970s, when it was replaced by offset printing and computer typesetting.

In 1966, Nick Ifft III implemented a plan to replace the *Journal's* presses and purchased a new Goss Urbanite offset press. According to the *Journal's* current website, the cost for this new press was $225,000. The first edition of the paper printed on this new press was available to customers on August 20, 1967. This purchase was a major technological advancement for the newspaper, because it allowed for the printing of sharper, clearer images and text. Offset presses also produce a more consistent high-quality image with less effort than letterpress methods. In offset printing, the image and background are not separated by height as they are in relief printing. Instead, this method takes advantage of the fact that oil and water repel each other. The way the oil and water are applied determines which areas of the image retain ink and are therefore printed.

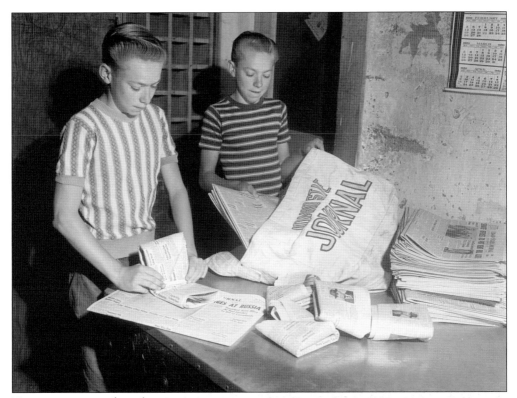

Newspaper carriers have been part of the newspaper experience from the beginning. In the early 1900s, newspapers were hawked on street corners or sold at newsstands. It was not until later that home delivery and daily subscription services became popular. Whether by bike or on foot, carriers always made sure their subscribers received the daily news. These images are from a Journal Paperboy Series of photographs from the *Idaho State Journal*. They were taken in Pocatello in 1952. At that time, newspaper delivery was a prominent part of keeping up to date on local news and events. It has since declined due to several factors, including the availability of news on the internet and changing employment laws.

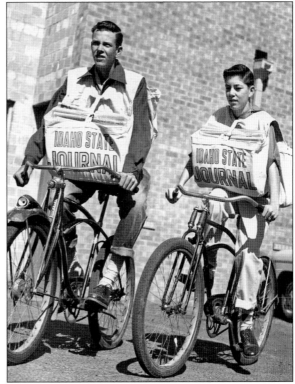

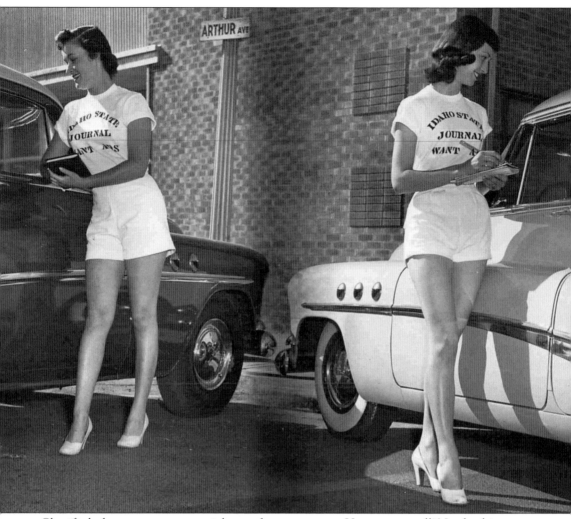

Classified ads were once an essential part of any newspaper. Have a car to sell? Need to hire a new employee? Placing an ad in the classified section is the perfect way to get the word out. Ads placed in the classified section, also known as "want ads," are visible to the newspaper's entire audience. This 1953 photograph shows *Idaho State Journal* employees taking ad orders from customers in the parking lot. The exact story behind the photograph is unknown, but current *Journal* employees believe it was staged as a spoof. As with many things these days, classified ads have found their way to the internet and are no longer limited to newspapers.

Two

THE EVOLUTION
OF POCATELLO

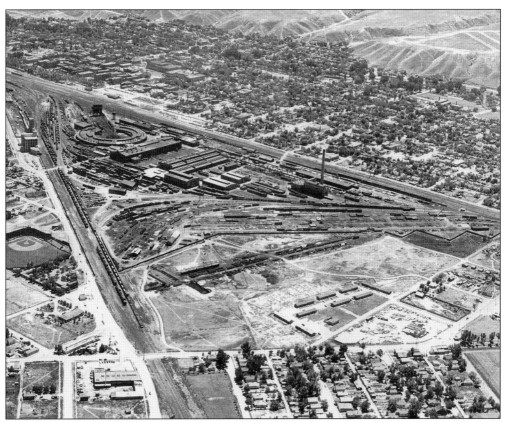

This aerial view shows Pocatello around 1970. Halliwell Park, at bottom left, hosted professional baseball earlier in the 20th century. Located on Alameda Road, the baseball field was named after a local pharmacist and baseball fan, Jack Halliwell. Within the hills at top are the nature trails of City Creek. Many locals and travelers traversed these trails on horseback, hiking, or biking. The circular structure at left is the roundhouse used by the railroad, which will be elaborated on later in this chapter. (Courtesy of BCHM.)

Throughout Pocatello's development, the railroad has played a key role in travel, business, and the community. It transported presidents, celebrities, and middle-class passengers to the heart of Pocatello and played a valuable role in the networking of residents and visitors. In 1881, the Union Pacific Railroad (above) built the Oregon Short Line Railroad from Granger, Wyoming, northwest to Oregon, following the Snake River through southeast Idaho. Other railroad lines followed, and Pocatello Junction, named because the town developed primarily around the merger of several railroad lines, was begun. Pocatello was an enormous railroad traffic center, necessitating the largest roundhouse in the Union Pacific system and a 900-ton coal chute. The turntable below allows locomotives to shift direction as well as to be repaired or stored. Behind the roundhouse, the shop at Pocatello was large enough to repair as many as 20 locomotives at a time.

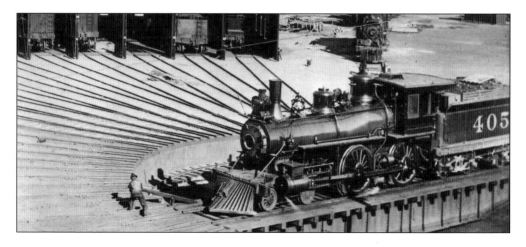

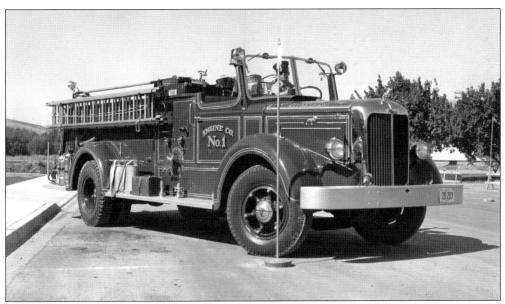

In 1886, the Pocatello Fire Department was established. At the beginning of the 20th century, the department relied upon horses to transport hoses and chemicals. It began utilizing automobiles such as the motorized truck by 1916. Interestingly, in the 1970s, the fire department oversaw ambulance and other important emergency services. In an *Idaho State Journal* article, John Farnsworth, a Pocatello firefighter celebrating his 98th birthday, was interviewed. He represents the many Pocatello firefighters who risked their lives in the early, highly hazardous days of the department. Workers did not have access to resources such as smoke masks or appropriately staffed crews. Nevertheless, Farnsworth fondly reminisced about the value of faith and community while serving as a firefighter. (Both, courtesy of BCHM.)

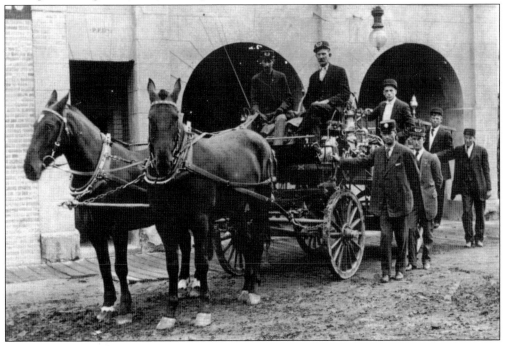

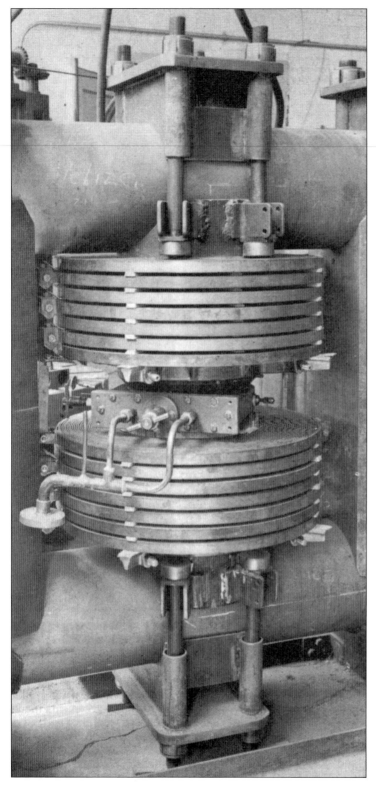

The Idaho National Engineering Laboratory (INEL), renamed in 2005 the Idaho National Laboratory (INL), remains one of the leading sources of nuclear energy, national security, scientific research, and environmental development for the country. This secretive government laboratory installed a facility in 1949 in rural Arco, Idaho, about an hour northwest of Pocatello. During this time, anything atomic was essentially a taboo topic due to the somber memory of the devastating bombing of Hiroshima. Nonetheless, the laboratory provided and continues to supply well-paying employment to numerous southeastern Idahoans. Pictured here is a 1958 cyclotron magnetic atom smasher, utilized in high-energy research. At this time, an INL branch resided at Idaho State College, now Idaho State University. (Courtesy of MPL.)

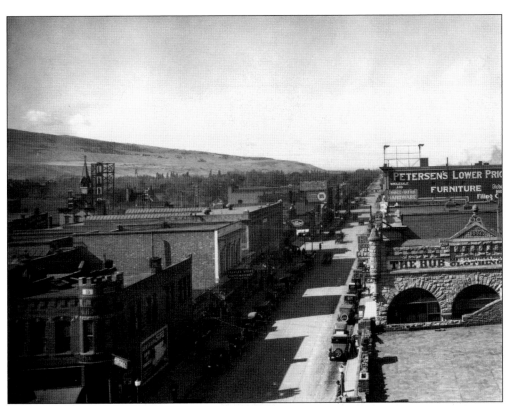

Pictured on the right in the image above is the Hub Clothing Company, constructed in the late 19th century and one of Pocatello's first stone buildings. This structure now houses the Paris at 102 North Main Street. Many businesses inhabited this bustling downtown location. The Old Town Residential Historic District contains 68 properties, the majority of which hold historical significance to the neighborhood. These buildings were constructed between 1892 and 1939 and represent the primary development of commercial activity, transportation, and social networking in Pocatello. Many architectural styles were found in the area. (Right, courtesy of MPL.)

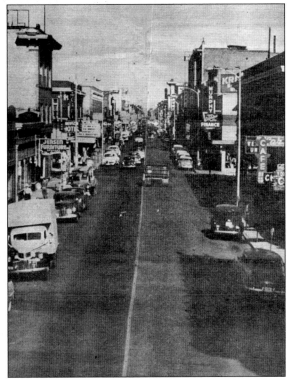

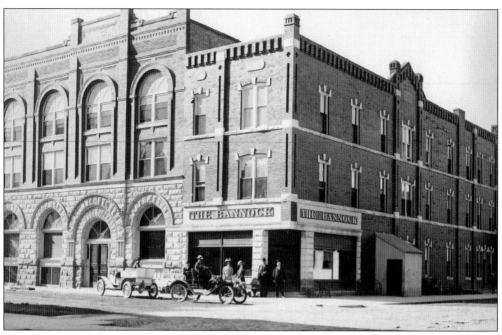

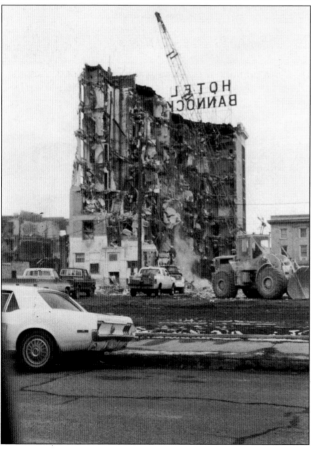

The redbrick Bannock Hotel, on the corner of Arthur Avenue and Center Street, was an important landmark in Pocatello. Designed in the Renaissance Revival style, it featured a series of round arches on the first three floors. Originally owned by the Kasiska family, it was purchased by Idaho governor and later US senator James H. Brady and a seven-story tower was added, making it the tallest building in Pocatello. The building was one of the most important in the city, partly due to the prominence of the owner. Many events, concerts, meetings, and dances were held in the ballroom, including a campaign speech by Sen. John F. Kennedy in 1960. Unfortunately, the Bannock Hotel suffered fire damage and was demolished in 1983 due to political reasons. Simplot Square now stands where the hotel was located. (Both, courtesy of BCHM.)

The People's Store, built around 1915, was a prominent clothing and goods business. Designed by Marcus Crundfor and built at 312 West Center Street, the structure contained two floors, the first occupied by the market. The second floor accommodated professional offices, including that of Oscar Sonnenkalb, who also owned the building and played an influential role in Pocatello's early evolution.

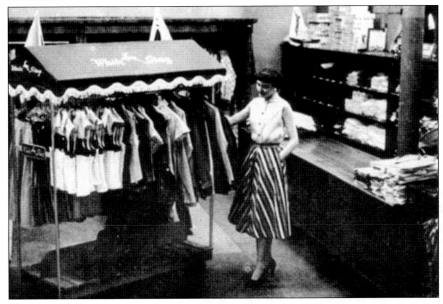

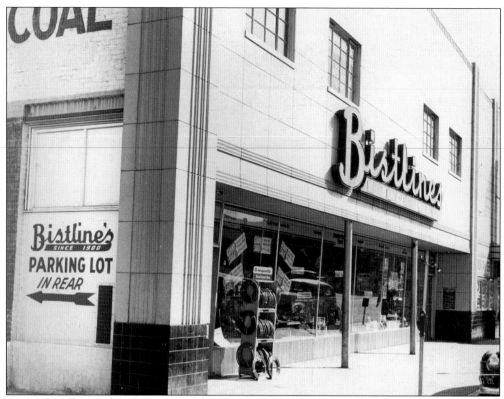

Bistline Lumber Company was founded by brothers Joseph B. and John M. Bistline, who moved to Pocatello together from Andersonburg, Pennsylvania. As Pocatello grew, the need for building materials increased and the business flourished. The Bistline family left an even greater legacy in civic affairs, however. Both Joseph and John served terms as mayor of Pocatello, and Joseph was the president of the Pocatello Chamber of Commerce. (Both, courtesy of BCHM.)

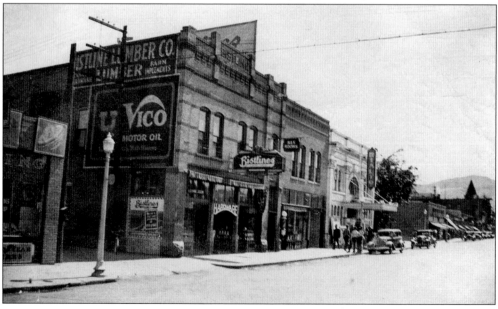

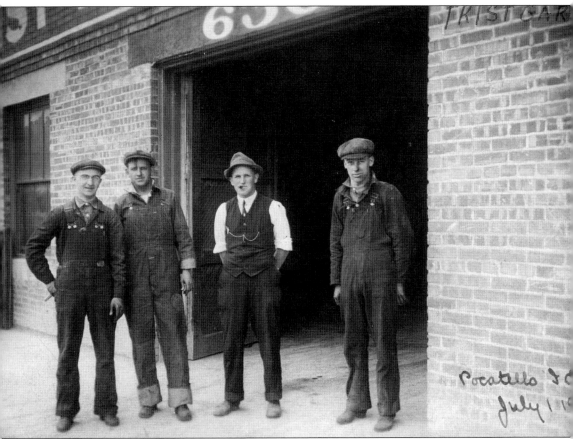

Mechanics stand in front of the Trist Garage building at 630 West Center Street in Pocatello in 1913. Trist Automotive opened in 1910 as a Ford dealership and sold 40 vehicles in its first year. It became Intermountain Chevrolet in 1936 and remained in downtown Pocatello until moving north to Garrett Way in 1963.

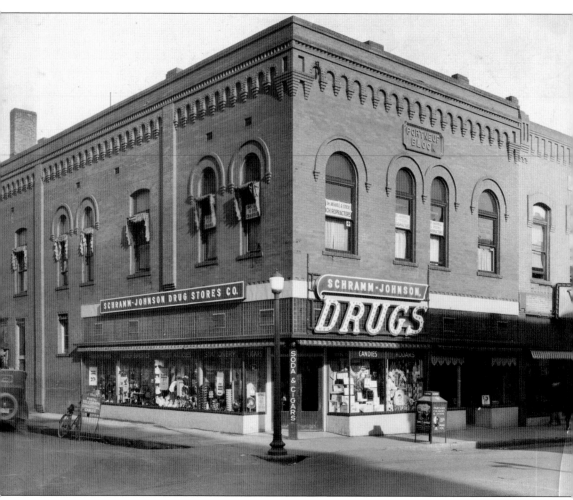

F.C. Schramm and Joy H. Johnson of Salt Lake City opened a location of their Schramm-Johnson Drug Store at the corner of West Center Street and Arthur Avenue in downtown Pocatello in 1923. With one of the leading schools of pharmacy in the West at what is now Idaho State University, Pocatello residents never had a shortage of drugstores to choose from. According to a 1950 article in the *Idaho State Journal*, in Pocatello's early years, the city had almost as many drugstores as bars. (Courtesy of BCHM.)

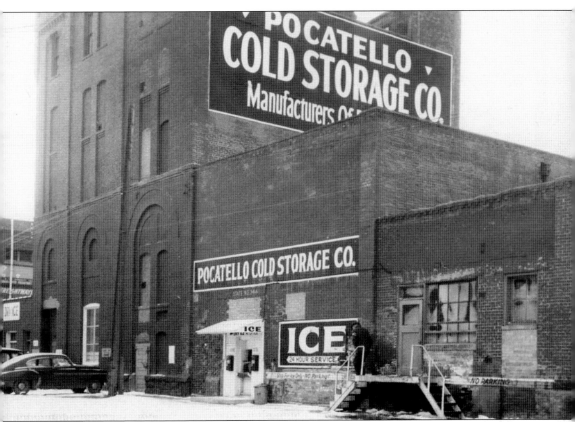

In 1914, the Pocatello Cold Storage Company was established by Lyman Fargo, J.B. Bistline, and T.H. Gathe. These owners occupied various important roles in the community, including being political leaders, lawyers, investors, and owners of various businesses. At this time, Pocatello had a population of only 2,500. At one point, the Pocatello Cold Storage Company was the largest plant of its kind in Idaho. It was responsible for creating 10 tons of ice per day. Becco, a nonalcoholic carbonated drink popular during Prohibition, was produced there. (Courtesy of BCHM.)

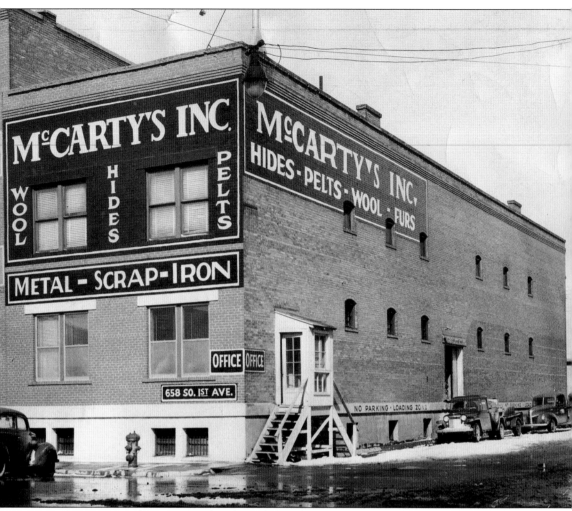

McCarty's was in the commercial and warehouse district east of the railroad tracks in Pocatello, across the street from what is today Portneuf Valley Brewery in the 600 block of South First Avenue. Established in Pocatello in 1892 by William McCarty, McCarty's originally sold hides, pelts, wools, and furs but transitioned to warehousing metal and scrap iron to support Pocatello's growth, the rising popularity of passenger vehicles, and the growth of the railroad. Unfortunately, McCarty's fell victim to one of Pocatello's infamous fires in June 1992. (Courtesy of the BCHM.)

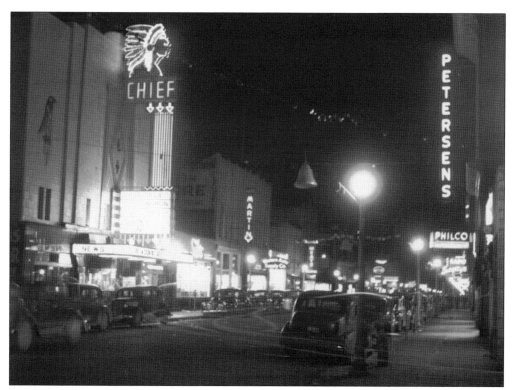

Opening in 1938, the Chief Theater, with its iconic neon sign, was a Pocatello landmark. The interior of the theater was beautiful and elaborate, with scenes of the Old West painted on the sides and buffalo medallions on the ceiling of the 900-seat auditorium. Closed in 1984 due to deterioration, it was donated to the city by its owner. The Chief Foundation was formed to restore the building to its former state, including installation of a new heating and cooling system. On March 20, 1993, the theater was gutted by a fire that started in the roof. The tile mosaic of an Indian chief from the lobby was salvaged, along with the neon Indian chief head sign. Both of these are now on display at the leveled site, next to the parking lot built where the theater used to stand, thanks to the efforts of the Relight the Night Committee. (Both, courtesy of BCHM.)

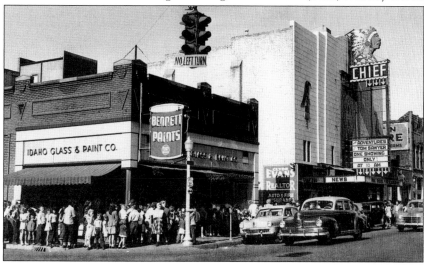

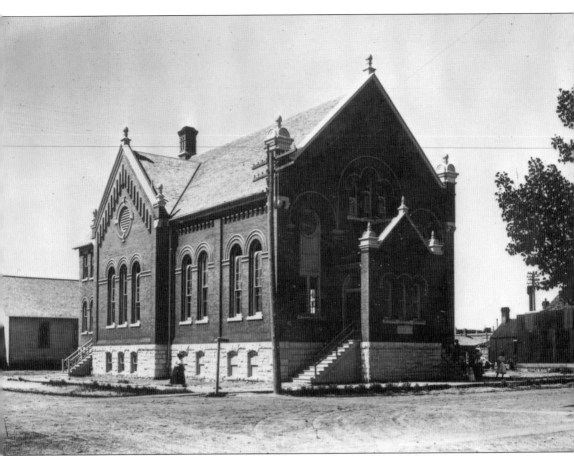

Throughout Pocatello's history, religious convictions shaped the town's layout. Many members of the Church of Jesus Christ of Latter-day Saints (LDS) wanted to separate from the "rough" elements of Pocatello's early days and settled to the north in the town of Alameda. Even though Alameda voted to merge with Pocatello in 1962, the borders are still clear at Oak Street, where the streets are slightly offset. Nonetheless, other LDS settled in Pocatello, and the First Ward building, constructed in 1903, is located on Center Street and Garfield Avenue. (Courtesy of BCHM.)

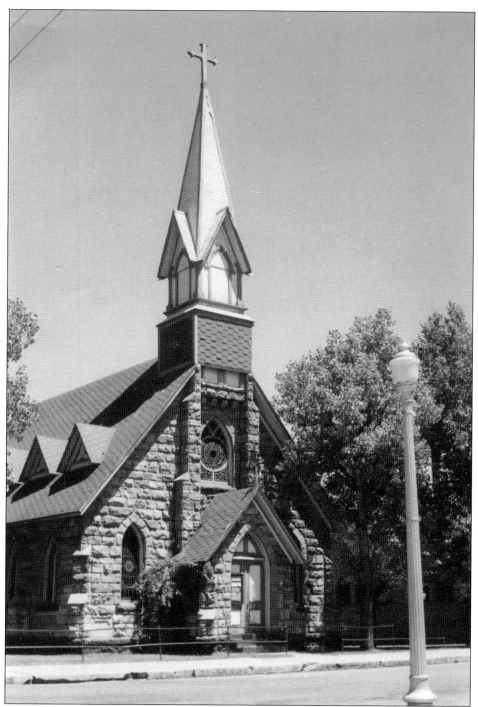

A number of venerable, aged church buildings grace downtown Pocatello, many of which still host active congregations. Trinity Episcopal Church, at 248 North Arthur Avenue, was built in 1898. The architecture represents the Gothic Revival style with buttresses, lancet windows, and arched portals. Its remains one of the few standing 19th-century churches in Idaho. (Courtesy of BCHM.)

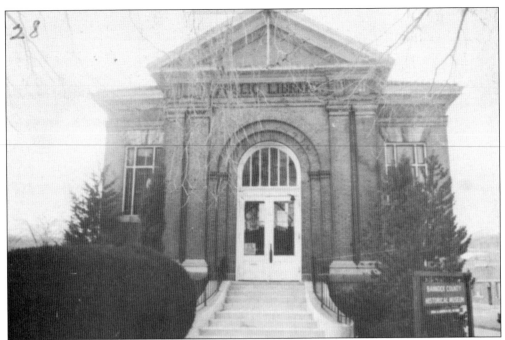

As a result of grants provided by multimillionaire Andrew Carnegie, almost 2,000 Carnegie libraries were built across the United States from 1901 to 1914. The Carnegie library in Pocatello (above) was constructed in 1907 using a $12,000 grant. It was Pocatello's first public library. The architecture provides a prime example of the Palladian villa style. The photograph below, from October 12, 1925, shows one of the library's early boards of directors. Members of the board were appointed, and included prominent citizens such as Eve Emma Stanrod (second from left), whose husband, B.W., was a well-known Pocatello attorney and himself an appointed member of Idaho's first public utilities commission. (Below, courtesy of MPL.)

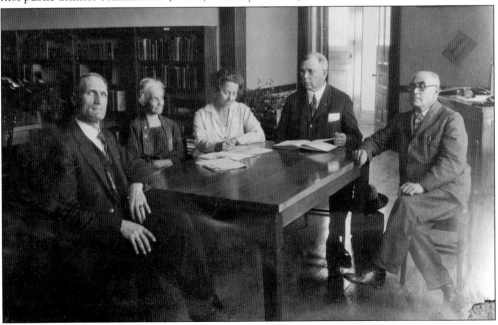

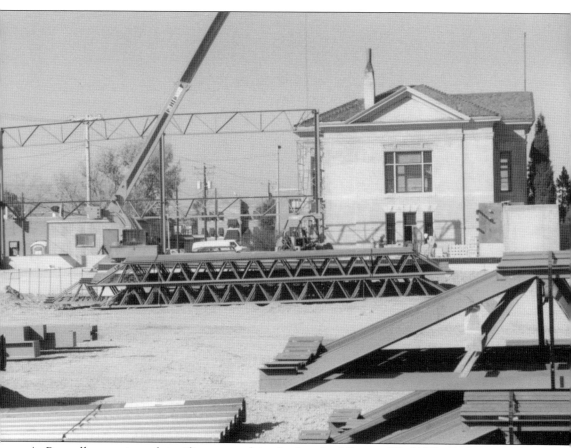

As Pocatello experienced significant growth in the decades following World War II, the original Carnegie library building on South Garfield Avenue became too small to house the city's collection, prompting a move to a new building on the east side of Pocatello on Seventh Street. In the early 1990s, Pocatello executed a plan to build an extension to the original Carnegie library building on adjacent land that had once been the site of some of the most fashionable homes in Pocatello, including those of Minnie Howard, the Kasiska family, and Edward Stevenson. The Barbara Marshall Library is named in honor of a key donor and longtime Pocatello resident.

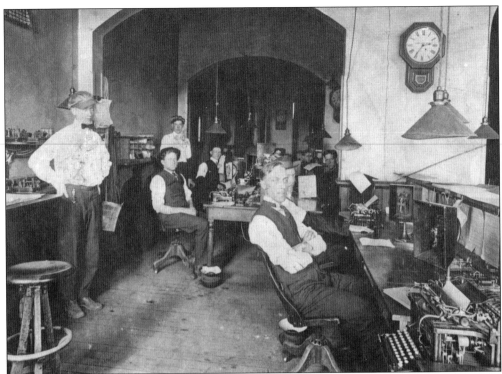

Communications were paramount in a growing railroad town like Pocatello. Originally, communications came primarily via telegraph. A group of telegraph operators for the Union Pacific Railroad pose in the 1914 photograph above. Later, the primary means of communication was the telephone. The Telephone Building (pictured below in 1976) was at the busy downtown intersection of South Arthur Avenue and West Lewis Street in Pocatello. The Telephone Building housed the multitudes of operators who manually connected the phone calls of Pocatello residents for much of the 20th century.

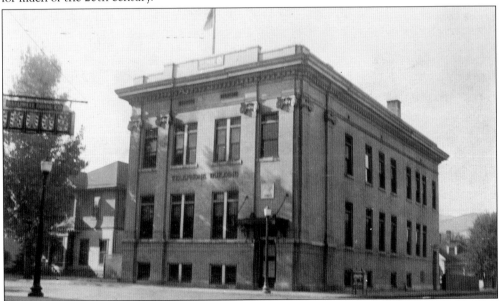

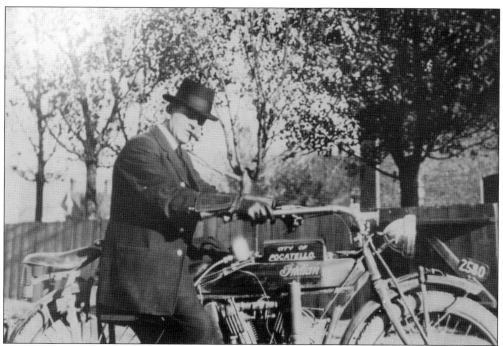

Pocatello was a city on the move, and the railroad was but one means of getting around. Above, one of Pocatello's first traffic officers, Jake Foster, rides around town on a 1915 Indian motorcycle. Below, Fred and Kelly's Café, the Ranch Room, and coffee shop beckoned motorists along Highway 91, the Yellowstone Highway (now Yellowstone Avenue in Pocatello). (Below, courtesy of BCHM.)

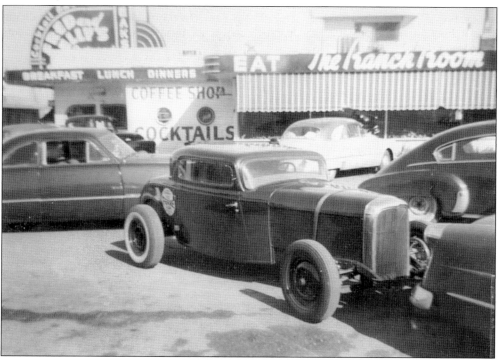

In 1928, J. Simons and J.B. Mayfield purchased 160 acres south of Pocatello along the west shore of the Portneuf River in Inkom and opened an Idaho Portland Cement plant. The plant capitalized on the vast quantities of limestone and silica in the surrounding hillsides that made excellent cement. The plant's location also made it prone to spring flooding of the Portneuf River, as in this photograph. The plant was eventually acquired by Ash Grove Cement.

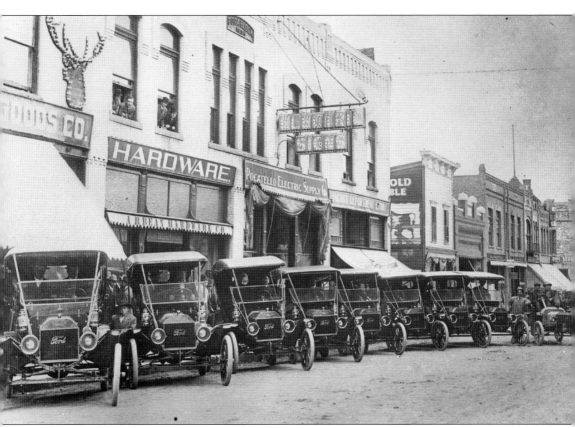

A row of Ford Model T passenger cars is lined up in front of A.B. "Ben" Bean's Hardware in the early 1910s. This photograph demonstrates how, in addition to hardware, Bean's carried Ford automobiles in the early days before the exclusive dealer system. Bean's Hardware was one of the first businesses on the west side of the railroad tracks in Pocatello when it was founded in 1892. It was sold to Vogt's Sheet Metal in 1915.

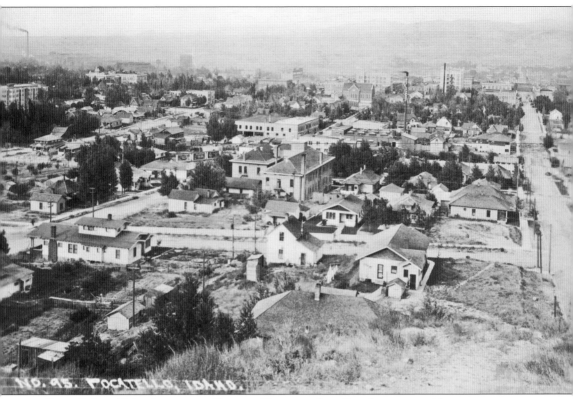

Pocatello's rapid development and heavy reliance on the railroad were not without consequences. In this 1920 photograph from Pocatello's West Bench, the view of the mountains on the other side of the valley is seriously compromised by air pollution from trains, factories, and the coal-burning stoves in most homes of the time. According to one story, Edward Stevenson, son of a superintendent of the Oregon Short Line Railroad, moved to Hollywood in 1922 to gain relief from a chronic respiratory ailment. His story, and others like it, suggest that the air quality in Los Angeles at the time was better than that of Pocatello!

Three

FEATURES

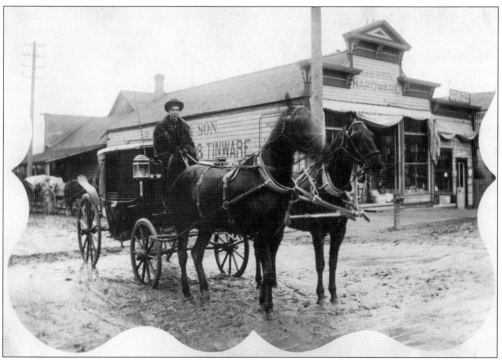

This photograph from the early 1910s shows the George Addy Hardware store on the corner of North Main and Clark Streets in Pocatello. George Addy's father, R.E. "Bob" Addy, was a tinsmith by trade but is better known as the inventor of the slide in baseball. He was a player for the Rockford (Illinois) Forest Citys in the late 1860s, a right-fielder for the pennant-winning Boston Red Stockings (of the old National Association) in 1873, and a player-manager of the Cincinnati Reds in 1877. (Courtesy of BCHM.)

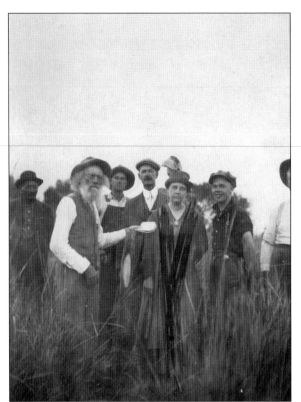

The photograph at left shows Dr. Minnie Howard with Ezra Meeker and their team, who discovered the original location of Fort Hall. Dr. Howard (below), a wife and mother of four, was one of only a few female physicians in the West during her time. She and her husband, Dr. William Howard, founded Pocatello's first hospital in 1905. In addition to her work in medicine, Minnie was an active and dedicated community member. Her fascination with the area's history led to her position as a Bannock County historian for 25 years and a columnist for the *Pocatello Tribune*. She also helped secure funding for the Carnegie library, saved many Native American artifacts, helped establish the Fort Hall replica, and aided in the creation of the Oregon Trail memorial half-dollar. (Both, courtesy of BCHM.)

Edward Stevenson, whose father was a railway supervisor, grew up in Pocatello next door to Minnie Howard's home, where Marshall Public Library now stands. Due to Stevenson's struggles with allergies, he and his mother would travel to California for the summers, and moved there permanently after his father died. It was in California that Stevenson found his love for design. In his childhood, he had learned how to draw through mail-in art lessons, and later in his life, he designed costumes for films including *It's a Wonderful Life* and *Citizen Kane*. A friend of Lucille Ball, he designed many of her costumes for the later seasons of *I Love Lucy*. He also advanced the field of costume design by researching the effects of various textures on actor comfort and the effects of colored fabric during television's transition from black and white to color. (Courtesy of MPL.)

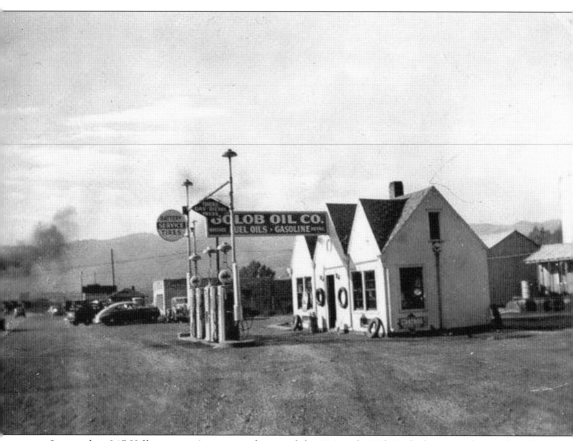

Located at 245 Yellowstone Avenue and part of the "Miracle Mile" of what was then Alameda, Golob Oil was founded in 1937 by Francis Golob and B.B. Schneider. As the exclusive Pocatello dealer of Standard Oil products, the facility focused primarily on heating oil but also had a gas station. Margaret Golob took over after the original owners retired and became the only woman to be a principal owner of a Standard Oil distributor in the Intermountain West. She was tough, working with trucking firms and making 2:00 a.m. house calls to customers whose heating oil ran out. In 1959, she made a dramatic $50,000 renovation of the company building, which included installing the largest neon sign in the city.

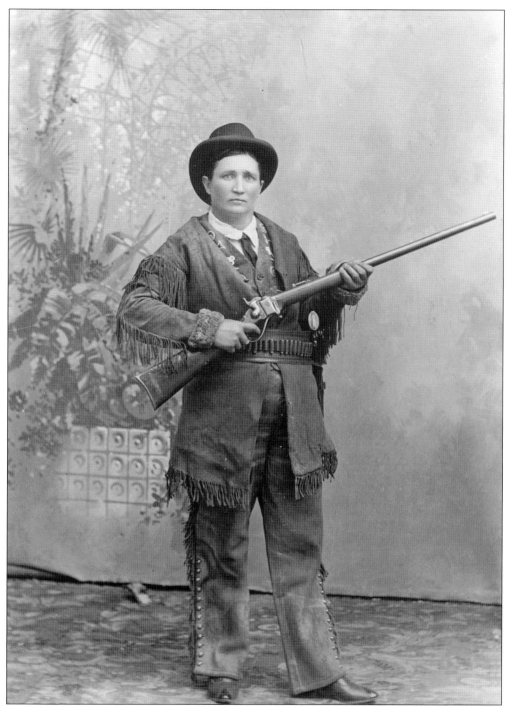

Martha Jane Cannary, better known as Calamity Jane, is a legendary character of the Wild West. Orphaned at the age of 12, she was left responsible for five younger siblings. Cannary worked various jobs to support her family, which led her to participate in some unsavory business. While she is known for her rowdy and wild character, she also had a softer side, and in 1888, she married William P. Steers in Pocatello. (Courtesy of BCHM.)

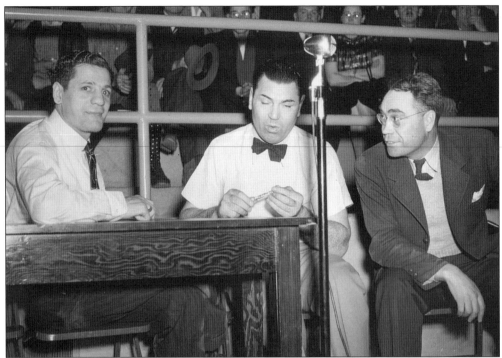

On December 11, 1958, Jack Dempsey, heavyweight boxing champion from 1919 to 1926, came to Pocatello to referee the Idaho State College boxing tournament. He was on a tight tour schedule between Salt Lake City and Los Angeles but made the stop when he heard kids in Pocatello wanted autographed gloves and pictures. He then donated his time to help with the tournament, because he wanted to promote collegiate boxing and help raise funds for scholarships. Born William Harrison Dempsey, his family had traveled during his youth around Utah and Idaho as his father looked for employment. Dempsey left home at the age of 16 and worked for a time in Pocatello as a potato farm hand, railway employee, and even as a bouncer for a business on the east side of town. (Both, courtesy of BCHM.)

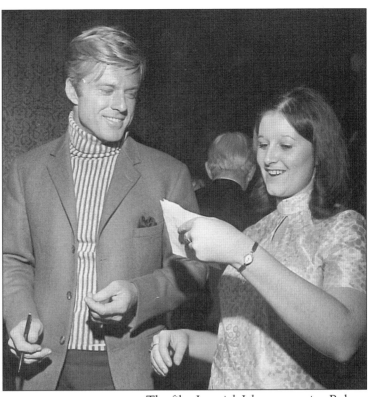

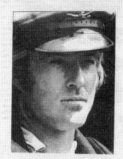

The film *Jeremiah Johnson*, starring Robert Redford, was released at the Chief Theater on November 17, 1972, one month prior to national release. The film was based on the book *Mountain Man* by Vardis Fisher, written as a tribute to his father and other men who founded what is now Ririe, Idaho, and whom Fisher believed to be the last of the true "mountain men." Redford, along with the movie's director, Sydney Pollack, and Opal Laurel Fisher, the author's widow, attended the premiere of the film and local media receptions. Boise and Pocatello had been selected as early release locations to honor the storyline of the book and the author's home state. The proceeds from the premieres funded a fellowship and literary scholarship in Fisher's name.

In 1968, performing artists John Carradine (left) and Julie London (below) performed at Idaho State University. Carradine, who has a star on the Hollywood Walk of Fame for his contributions to film, presented a program in Frazier Auditorium with pieces ranging from Shakespeare to Lewis Carroll. Four of his five sons followed in his footsteps to become actors. Julie London was an actress and singer whose talent was discovered while working as an elevator operator. She released 32 albums in 20 years, with her signature song being "Cry Me a River," written by her high school classmate Arthur Hamilton. In addition to singing, she had a 35-year acting career. (Both, courtesy of ISU.)

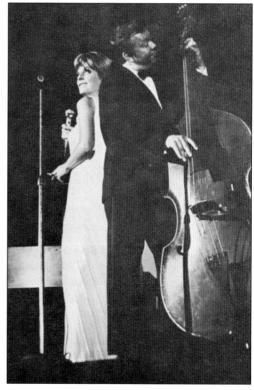

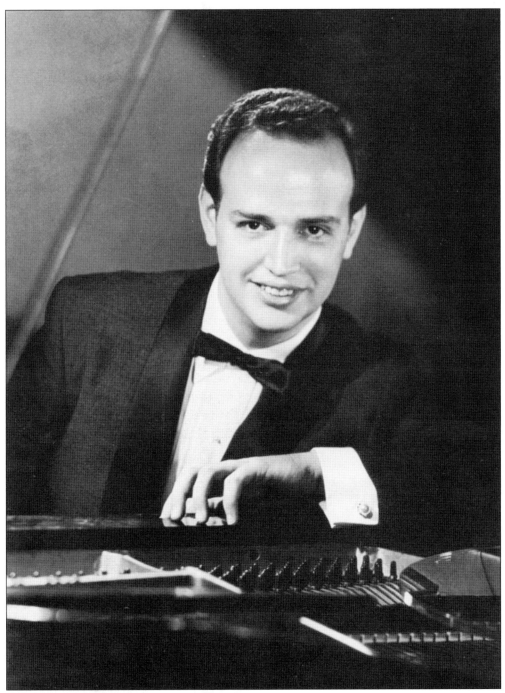

Roger Williams is one of the best-selling pianists of all time. After serving in the Navy after World War II, Williams attended Idaho State College (now Idaho State University), where he earned his bachelor's degree in 1949. His song "Autumn Leaves" is the only piano instrumental to hit number one on Billboard's pop music chart. In addition to releasing more than 100 albums, Williams played for nine presidents and was the first pianist to receive a star on the Hollywood Walk of Fame. (Courtesy of ISU.)

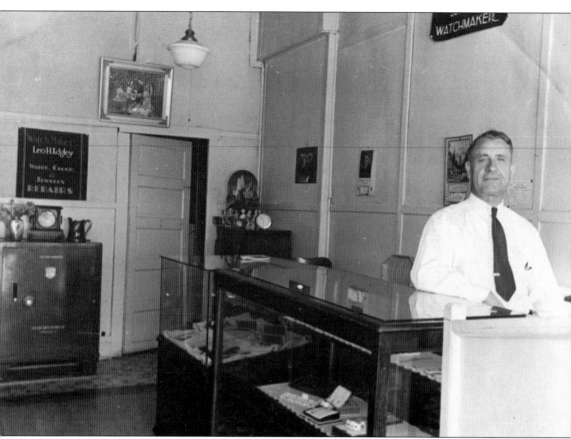

This 1940s photograph shows the interior of Edgley's Jewelry, located at 117 North Main Street and owned by Leo Edgley. Watchmaking was a critical trade in a railroad town like Pocatello, as precision instruments allowed for greater efficiency and timeliness of railway service. Leo's wife, Ethel Harrison Edgley, is believed to have been the first student to enroll at the Academy of Idaho (now Idaho State University), and one of their sons, Howard, became a charter member of the American Watchmakers Institute. (Courtesy of BCHM.)

Edgar Rice Burroughs, the author of *Tarzan*, owned a stationery shop in Pocatello from 1898 to 1900. In his youth, he moved to his brothers' ranch in American Falls, but he moved back to Pocatello after his service in the military. During the years he owned the store, he wrote stories on the back of pamphlets, such as *Minidoka: 937th Earl of One Mile*, which was not published until almost 100 years later. During his free time, Burroughs helped his brothers on their ranch in American Falls and frequented many of the local saloons. He also enjoyed photography and often submitted images to the *Pocatello Tribune*. (Both, courtesy of BCHM.)

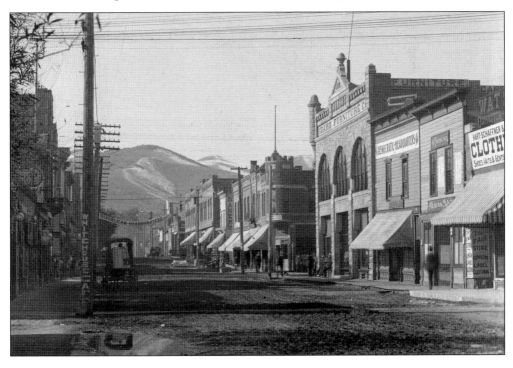

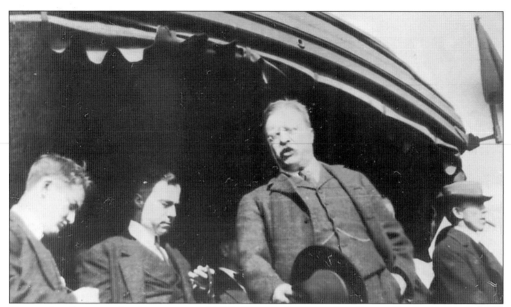

During his famous whistle-stop tour, Teddy Roosevelt stopped in Pocatello on September 19, 1900 (above). Due to Pocatello's strategic location on the Union Pacific railway line, the town was a major hub for travelers heading west. Numerous US presidents and other national figures stopped in Pocatello during their tours of the West. Many of them wrote about their positive experiences in Pocatello, including Eleanor Roosevelt, who wrote in her journal, "I found it a very charming small city." Eleanor stopped in Pocatello on multiple occasions, including in 1950 (below), when she was greeted by traffic officer Jim Moldenhauer (right) and F.M. Bistline (left). (Below, courtesy of Kathy Albano.)

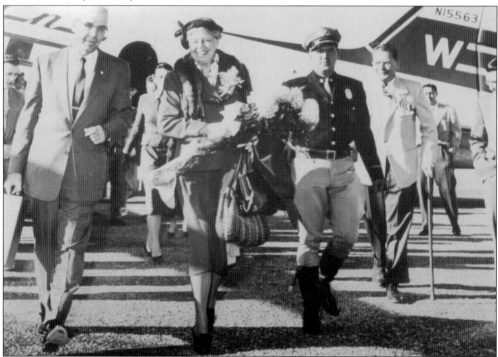

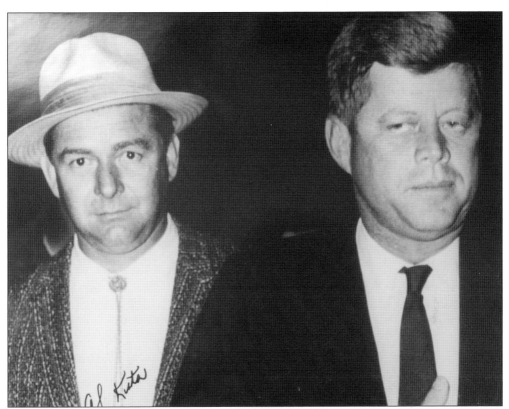

On September 6, 1960, John F. Kennedy (pictured above with Al Kuta Sr., who was assigned to show Kennedy the area's nightlife) visited Pocatello. While his visit was short, it left a lasting impact. Even today, many people remember the excitement that surrounded his visit and fondly recall the moment they met the presidential candidate. Kennedy landed in Pocatello with Idaho senator Frank Church (right). Church was passionate about international relations, was chairman of the Senate Foreign Relations Committee, and is the namesake of the Frank Church Symposium (now held at Idaho State University). Church and Kennedy entered the Senate within a few years of each other and bonded quickly over their time in World War II. Kennedy named Senator Church the keynote speaker of the 1960 Democratic National Convention. During the visit, Kennedy addressed a crowd of more than 3,000 people at Pocatello High School. (Right, courtesy of ISU.)

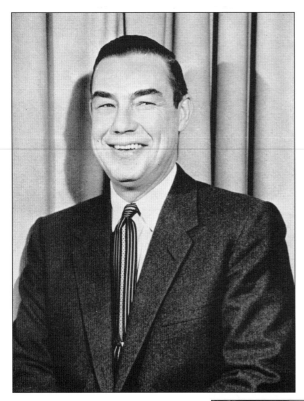

The only Idaho governor to serve three consecutive terms, Robert E. Smylie's career and impact on the state of Idaho was prolific. He was named state attorney general at 33, established the Idaho State Parks Department, helped eliminate term limits for governors, and instituted a five-day work week for state employees. Smylie was widely known in the political circles of Washington, DC, and was considered as a Republican vice presidential nominee in 1968. In 1963, Governor Smylie signed the bill that transitioned Idaho State College to Idaho State University.

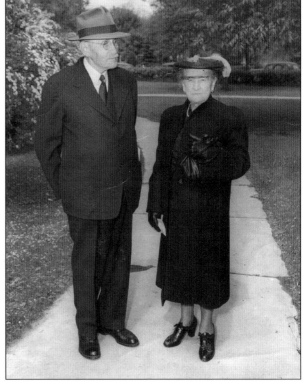

In his esteemed professional and congressional career, Theodore Turner was an Idaho senator, postmaster of Pocatello, mayor of Pocatello, and deputy clerk of the federal court. Known as the "Father of Idaho State College," Senator Turner drafted Senate Bill 53, signed by Gov. Frank W. Hunt on March 11, 1901, which established the Academy of Idaho in Pocatello. In the decades that followed, the Academy of Idaho would become Idaho State College and Idaho State University. (Courtesy of BCHM.)

Four

ENTERTAINMENT AND RECREATION

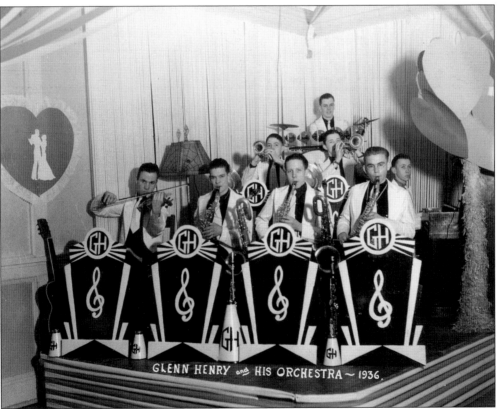

Beginning his musical career at the University of Idaho–Southern Branch in Pocatello in 1934, Glenn Henry (pictured playing the saxophone, first row, second from right) and his orchestra entertained the West Coast with his big band music for decades, including a Pacific Coast United Service Organization (USO) tour during World War II. This type of entertainment was a staple throughout the 1930s and 1940s and into the 1950s. (Courtesy of BCHM.)

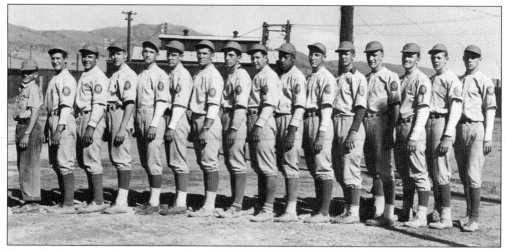

Pocatello has enjoyed many minor-league baseball games over the years. In a period from 1926 to 1993, Pocatello experienced 35 seasons of minor-league baseball. The farm teams for various major-league organizations that called Pocatello home included the Pocatello Bannocks, Cardinals, A's, Giants, Chiefs, Gems, Pioneers, and Posse. Pictured here is the Cardinals' first season lineup in Pocatello in 1939.

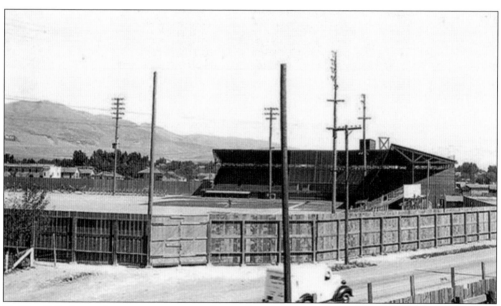

Halliwell Park was host to many minor-league baseball teams between 1930 and 1965. Hall of Famer Tommy Lasorda, prior to managing the Los Angeles Dodgers, managed the final Pocatello Chiefs season in 1965 before the ballfield was demolished and replaced by a shopping mall.

In addition to many organized sporting teams, pickup games were a great way to get together with friends and enjoy an evening. Pocatello has enjoyed a healthy sporting tradition since the town's inception. Pocatello High School and the Academy of Idaho (now Idaho State University) began a tradition of sporting excellence that has continued over the years, producing Olympians and professional athletes including Dubby Holt, Ed Sanders, and Stacy Dragila. (Courtesy of BCHM.)

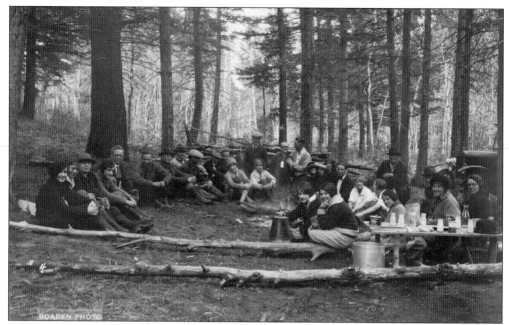

Pocatello has remarkable natural beauty, surrounded by mountains on three sides (south, east, and west). The mountains and valleys surrounding Pocatello have provided enjoyment for hikers and adventurists for over a century. Individuals in organizations like this Sky Time Club in the 1920s experienced camaraderie and invigoration in the woods and summits of Scout Mountain and Bonneville Peak. (Courtesy of BCHM.)

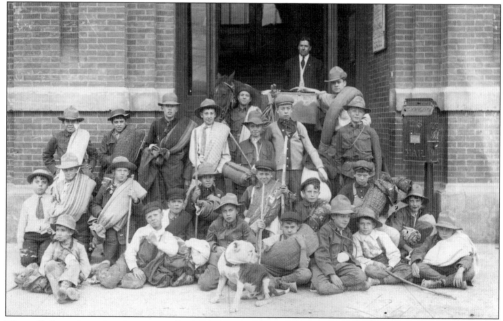

Two all-American institutions, the YMCA and Boy Scouts of America, join together in this photograph from 1912. Each boy is ready for adventure with his walking stick and bedroll. The skills these boys learned in these programs surely served them well over the years, as much of their adult lives involved the upheaval of World War I and the Great Depression. (Courtesy of BCHM.)

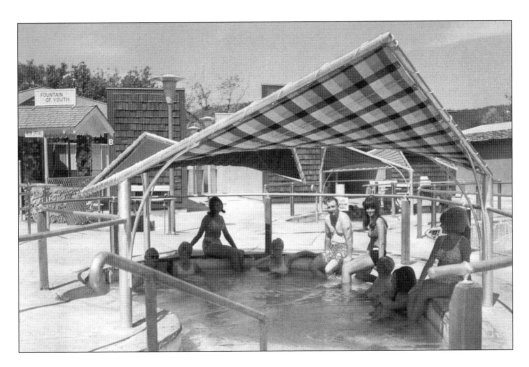

Pocatello may be landlocked and far from the ocean, but that has not prevented residents from taking a refreshing dip year-round. Just 36 miles from Pocatello, the hot mineral water of Lava Hot Springs (above) has served as a year-round recreational retreat for locals and travelers alike since the construction of a local train depot in 1905. Below, children can always be found enjoying a summer afternoon at the Ross Park Swimming Pool. Ross Park has been a center of recreation on the south end of Pocatello since the 1930s. (Above, courtesy of BCHM.)

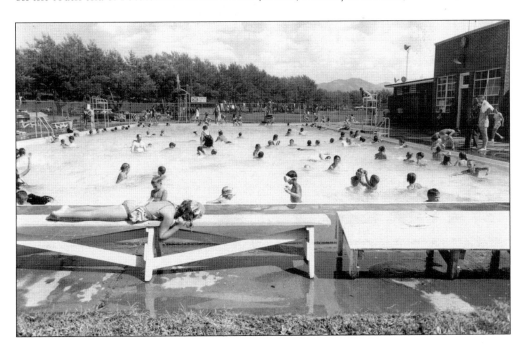

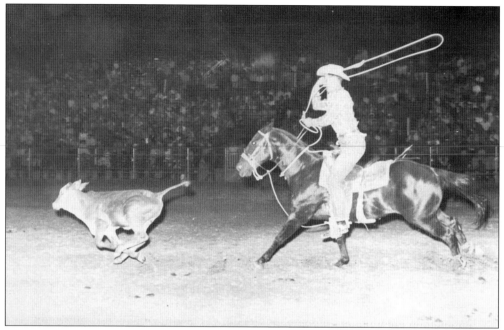

From the Victory Rodeos that started in the early 1940s to entertain troops stationed in Pocatello during World War II, Pocatello has hosted many rodeo competitions throughout the years. Above, a rider and his horse participate in the calf-roping event under the spotlights of the arena before a packed house. Below, from inside the rodeo arena to the outside arena of the surrounding hills, rodeo events always draw crowds. (Both, courtesy of BCHM.)

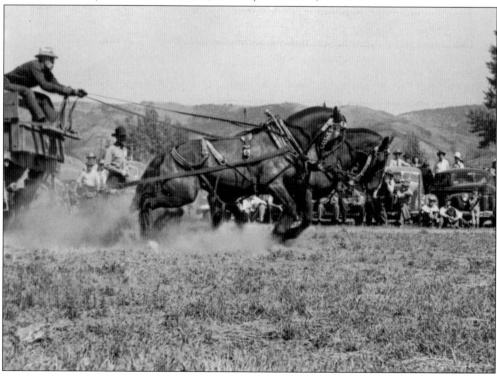

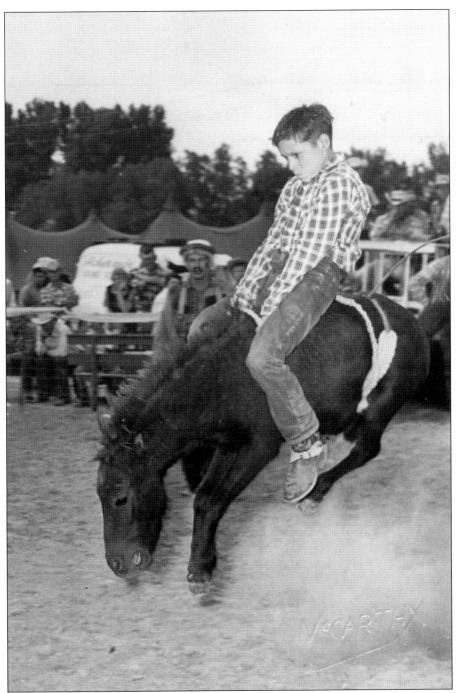

The allure of the rodeo has caught the imagination and excitement of Pocatello's youth from an early age. Kids like the one pictured here had plenty of role models in the outdoor rodeos at the Bannock County Fairgrounds and other outdoor venues in town. The next generation got to see indoor, big-time rodeo when the Dodge National Circuit Finals Rodeo came to Idaho State University's Holt Arena in Pocatello in 1987. The event remained in Pocatello until 2010, when it was moved to Oklahoma City. (Courtesy of BCHM.)

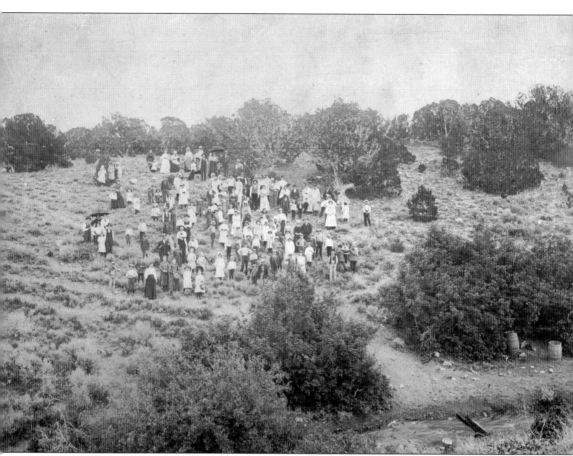

An LDS congregation enjoying a Sunday school picnic along the banks of City Creek in the summer of 1897 embodies the values of faith and community long held by the residents of Pocatello. The City of Pocatello purchased the City Creek Management Area, now a popular recreational area within the city limits, for cyclists, joggers, and pedestrians, from the US federal government in 1920. The transfer of land, which was finally signed by Pres. Calvin Coolidge in 1927, has since been extended to encompass nearly 3,000 acres in Pocatello's west foothills. (Courtesy of BCHM.)

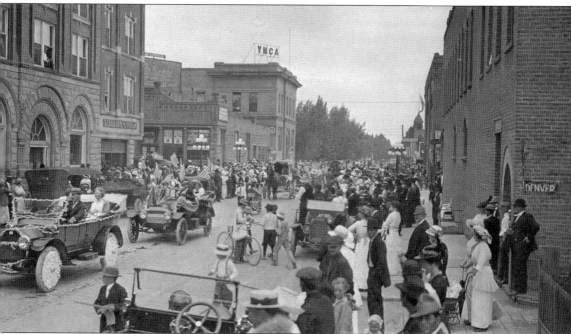

Parades are a great way to spend an afternoon and bring a community together. Here, in 1908, Pocatellans gather for the Fourth of July parade on Arthur Avenue near the Bannock Hotel. Pocatello has celebrated Independence Day with a parade for over 100 years and has showed its patriotism in other ways. For instance, the streets of Pocatello running north-to-south on the west side of the railroad tracks are named after the US presidents of the second half of the 19th century, from Buchanan to Harrison. (Courtesy of BCHM.)

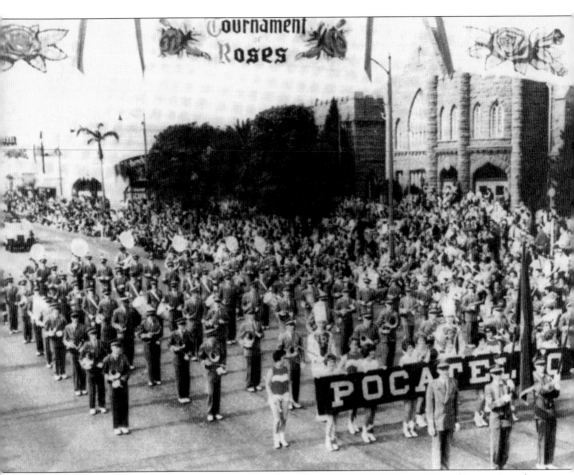

The Pocatello High School marching band performed in the Tournament of Roses Parade in Pasadena, California, on January 1, 1963. It was a significant achievement for a small town in southeast Idaho to be represented in one of the most well-known and nationally watched parades of the time. The band enjoyed a huge community sendoff early on December 28, 1962, and was greeted by a cheering crowd upon its return to Pocatello late on the night of January 2, 1963. The community was extremely supportive and proud to be represented by its high school's band on the national stage.

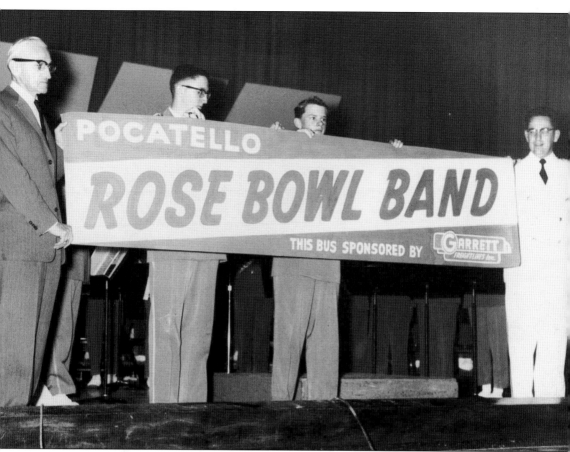

Many individuals and businesses volunteered to support the Pocatello High School band's travel to the Rose Bowl Parade in 1963. For instance, Idaho Power supplied light bulbs that the students sold to raise funds for the trip. The three buses used to transport the band members and their instruments from Pocatello to Pasadena, a total distance of some 1,900 miles, were cosponsored by Garrett Freightlines and the Union Pacific Railroad. (Courtesy of BCHM.)

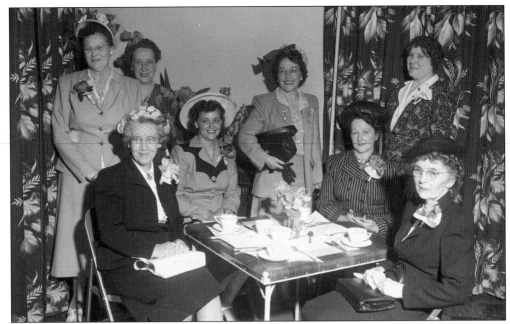

Many residents of Pocatello have enjoyed the association and camaraderie of social clubs. Men and women throughout the town's history have gathered to participate in service opportunities or to enjoy shared hobbies and interests. Above is a photograph of the Pocatello Women's Club enjoying a breakfast meeting in June 1950. Below, a group of businessmen decided to mix business and pleasure by enjoying an outdoor picnic in the summer of 1906. (Above, courtesy of ISU; below, courtesy of BCHM.)

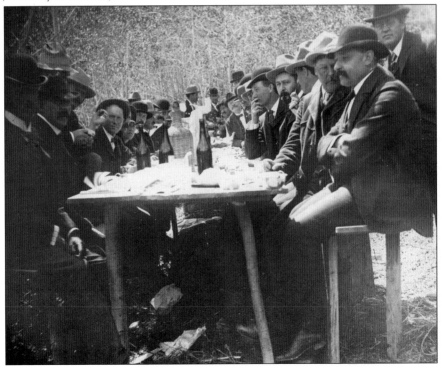

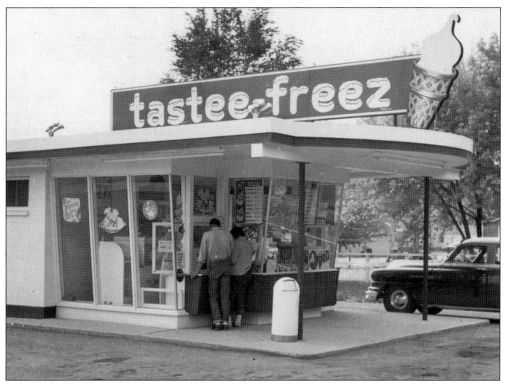

After an afternoon at the Ross Park Swimming Pool or before a movie at the Chief Theater, Tastee-Freez was one of many places in Pocatello to grab a quick bite. Tastee-Freez was one of the first drive-in restaurants in town. Eateries have evolved from the saloons of the late 1880s (below) to fast-food drive-ins of the 1950s to today's culinary variety of fast food, fine dining, All-American, and international fare. (Both, courtesy of BCHM.)

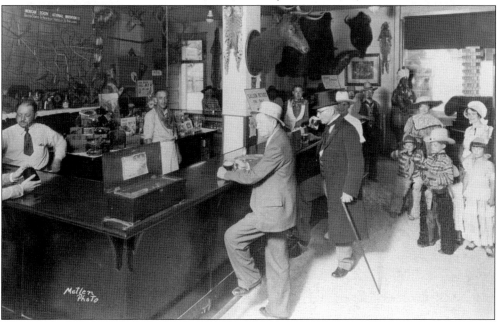

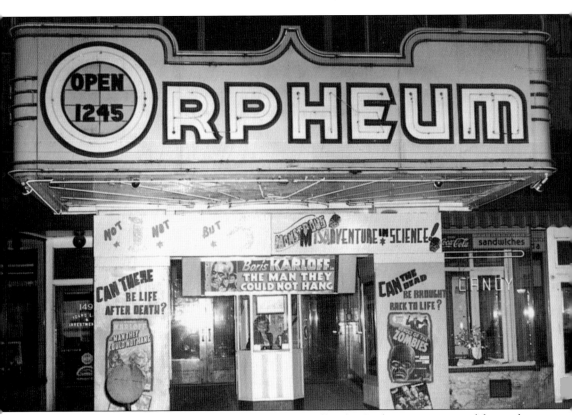

One of several destinations to catch a show in Pocatello, the Orpheum transitioned from a live-show theater in the early 1900s to a second-run movie house in the 1940s. Before falling victim to a fire in 1973, the Orpheum Theatre was a prime place for an evening of entertainment.

Five

WAR TIMES IN POCATELLO

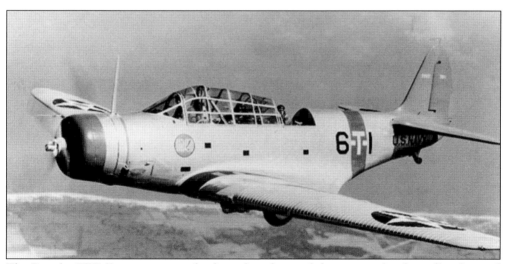

The Douglas TBD Devastator was the first of its class and the most technologically advanced airplane when it was created in 1935. It was one of the types of aircraft that landed at the new US Army airfield west of Pocatello beginning in 1943. Following the war, the airfield was sold to the City of Pocatello, and the Pocatello Regional Airport continues to operate at that location today.

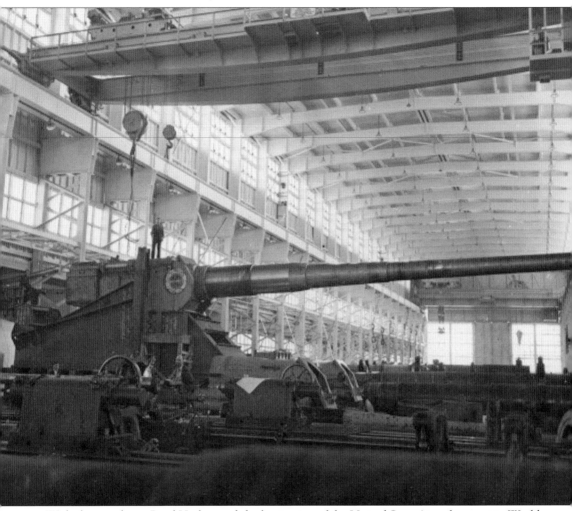

With the attacks on Pearl Harbor and the beginning of the United States' involvement in World War II, many weaponry facilities popped up around the country. One of those was the Pocatello Naval Ordnance Plant. The plant was responsible for producing needed weaponry to support the war effort. The skilled machinists and mechanics working at the facility repaired naval guns such as this massive gun that was mounted on US battleships. The plant was also involved in the manufacturing, rebuilding, overhauling, and assembly of other naval weapons. At its peak, 1,268 people were employed at the Pocatello Naval Ordnance Plant, making it the second largest single industry in Idaho. Pocatello's Union Pacific Railroad terminals and transcontinental highway system made it the perfect location, near the West Coast yet nestled by the Rockies to avoid a surprise attack. The plant was briefly closed after World War II but was reopened due to the Korean War and then remained open until the mid-1950s.

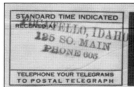

Postal Telegraph

Mackay Radio All America Cables
Commercial Cables Canadian Pacific Telegraphs

```
SX2   77 GOVT 6 EXTRA CHECK US DELS   OR OL CHGS=DX WASHINGTLN DC

MRS J J EVERSOLE=                                          18 203A
                                                  JUN 18  AM 8 08
    137 ROOSEVELT AVE POCATELLO IDAHO=

THE NAVY DEPARTMENT  DEEPLY REGRETS TO INFORM YOU THAT YOUR SON
LIEUTENANT JUNIOR GRADE JOHN THOMAS EVERSOLE UNITEDSTATES NAVY IS
MISSING FOLLOWING ACTION IN THE PERFORMANCE OF HIS  DUTY AND IN TH
SERVICE OF HIS COUNTRY X THE DEPARTMENT APPRECIATES YOUR GREAT
ANXIETY AND WILL FURNISH YOU FURTHER INFORMATION PROMPTLY WHEN
RECEIVED X TO PREVENT POSSIBLE AID TO OUR ENEMIES PLEASE DO NOT
DIVULGE THE NAME OF HIS SHIP OR STATION=
    REAR ADMIRAL RANDALL JACOBS CHIEF OF THE BUREAU OF NAVAL
PERSONNEL.
```

Postal Telegraph
COMMERCIAL CABLES • MACKAY RADIO • ALL AMERICA CABLES • CANADIAN PACIFIC TELEGRAPHS

The Battle of Midway was a key turning point in the US naval campaign of World War II, and Pocatellans Tom Eversole and Norman Kleiss were involved. Enrolled in the US Naval Academy and graduating in 1938, Eversole and Kleiss went straight aboard the USS *Enterprise*. Kleiss recalled in an *ISJ* publication, "If you got orders to the *Enterprise*, you were something pretty special." Upon arrival, they began flight training. Kleiss manned a plane that performed well, but Eversole's plane was a cause for concern. Both knew that if Eversole ever had to fly, it would be a suicide mission. In 1942, the *Enterprise* cracked the Japanese code, heard their attack plan, and immediately set out seeking confrontation. Two weeks later, a telegram came to Eversole's household in Pocatello stating he was missing in action.

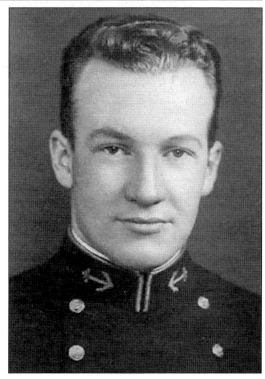

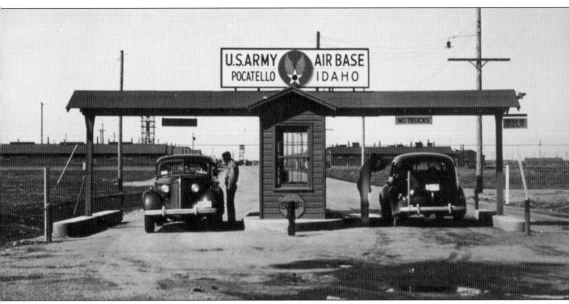

Construction on the US Army airfield in Pocatello began in April 1943, and the field became operational by late October. The purpose of the airfield was for heavy bomber training for B-17 and B-24 aircraft crews and P-39 and P-47 fighter pursuit pilots. With the construction of the base came the construction of the bombing field. The Pocatello Bombing Range was built and used as a demolition and incendiary bombing field for the aircraft crews and fighter pursuit pilots. Six bombardment groups were stationed at the Pocatello Army Airfield along with two fighter squadrons, all of which had access to the bombing range. The total number of bombs that were dropped in Pocatello has been lost in history. However, according to a US Army Corps of Engineers fact sheet, a single bombardment group dropped around 1,700 practice bombs and 95 demolition bombs.

Drafted in 1942, Clarence Vickery was sent to Sacramento, California, for basic training. Originally training to be sent to the South Pacific, an infection prevented him from shipping out. Once healed, Vickery was sent to England to begin training for the Normandy invasion. "There were American dead everywhere on the beach," Vickery recalled in an interview with the *Idaho State Journal.* "It was so terrible and I was kind of shook up, but we were trained to do a job and we just could not think about it."

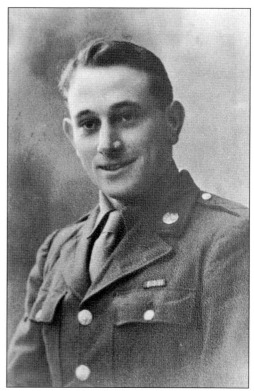

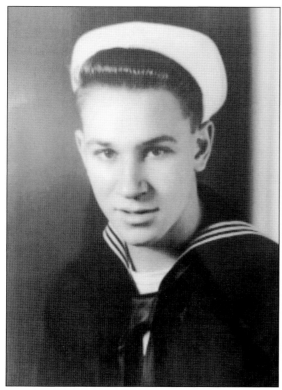

Doug Trego was drafted for World War II when he was 17. He attended basic training in San Diego, California. Stationed on the USS *Pasadena*, Trego was right in the middle of Okinawa and Iwo Jima. Trego's job was to operate the computer systems in charge of calibrating the five-inch guns ensuring the rounds exploded just before their target. The *Pasadena* was 100 miles offshore when the atomic bombing in Hiroshima led to the end of the war.

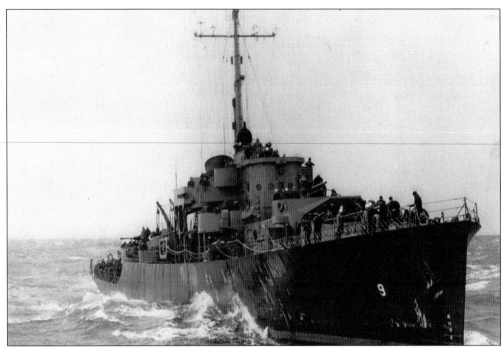

The USS *Pocatello* was one of 75 US Navy Tacoma-class patrol frigates. It was constructed in 1943, and Thelma Dixey, great-granddaughter of Chief Pocatello, was the sponsor of the ship. Even though this was a Navy ship, it was manned by members of the US Coast Guard. The responsibilities of the ship were vast and numerous. Running convoy for merchant ships, making rescue missions for downed aircraft, offering fire cover for ships landing troops on the Japanese-held Pacific islands, and most of all aiding in the Normandy landings, the *Pocatello* was just as busy as convoy vessels. The main task was taking weather readings and reporting to the Port of Seattle. Alternating 30 days at sea and 10 days at port, the *Pocatello* spent over one whole year at sea before the end of the war.

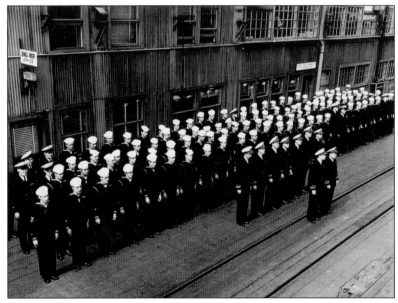

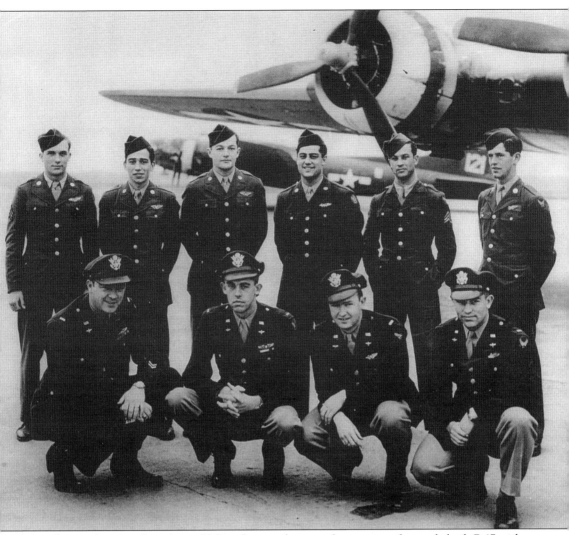

David Ririe, from rural southeast Idaho, along with nine others, manned a newly built B-17 with a goal of bombing a target in Rostock, Germany. Upon doing so, their plane was hit and crash landed in Nazi territory. Ririe and the others were captured and became prisoners of war in April 1944. Ririe stated in an interview with the *Idaho State Journal* that "We always knew that the U.S. would win . . . we had complete confidence, it was just a matter of time." Ririe and the other men devised several escape plans, but none of them were realistic. He recalls the main problem with tunneling was what to do with the soil; they ended up deciding to hide the soil in their own cots. While the war was going on outside the camp, roll call, church services, softball games, and practical jokes were happening inside the camp. Once the camp was liberated by the Russians, Ririe returned home and continued his education to receive his doctorate in agronomy. He now resides in California with his sweetheart of 66 years.

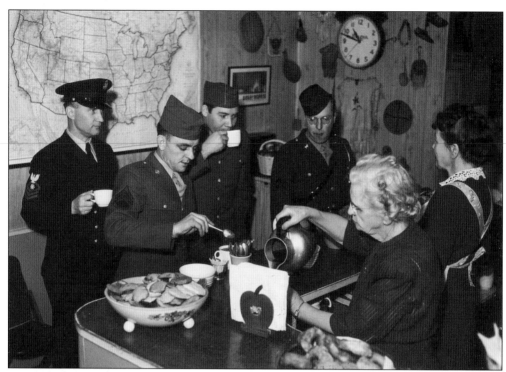

Coffee, milk, sandwiches, and cake were all served at the USO office in Pocatello. There were around 3,000 USO clubs worldwide that provided many services to the individuals who worked and served in World War II. Military men and women gathered here for a break after traveling on the Union Pacific Railroad. Many events were hosted for the servicemen and -women to provide a relaxing and fun time between their travels. USOs were famously known for their live performances, called "Camp Shows." Over 4,000 shows were performed worldwide with famous entertainers such as Abbott and Costello, the Andrews Sisters, Fred Astaire, Lucille Ball, Desi Arnaz, and Lauren Bacall, to name a few.

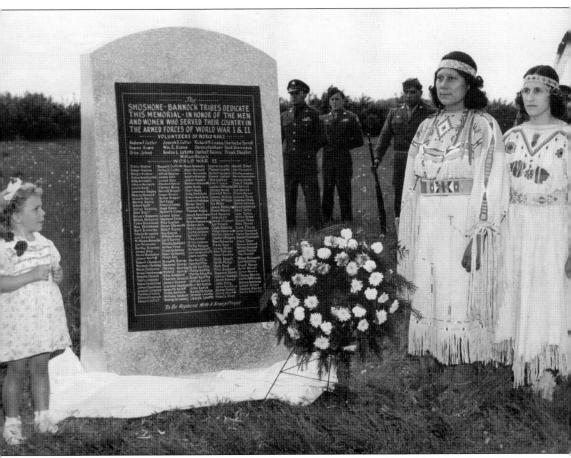

The costs of war were borne by a wide range of Pocatellans and southeast Idaho residents. This photograph from the late 1950s shows the dedication of the Fort Hall Veterans Memorial Park along US Highway 91 north of Pocatello. The memorial commemorates the sacrifices of soldiers from the Shoshone-Bannock tribes who gave their lives in World Wars I and II.

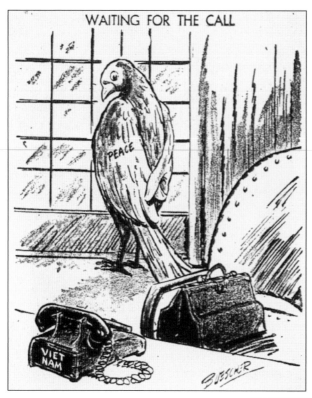

WAITING FOR THE CALL

Unlike previous wars, the Vietnam War (and the troops who fought in it) became increasingly unpopular at home, as demonstrated by these political comics that appeared in the *ISJ*. Many of the residents in Pocatello were displeased by the Johnson administration's decisions to escalate the bombing of Vietnam and vicariously blamed the men and women who served in the military. Oliver Hartwig, a Vietnam veteran from Pocatello, told the *ISJ* that in his return after serving, "An old high school girlfriend called me everything but a human being."

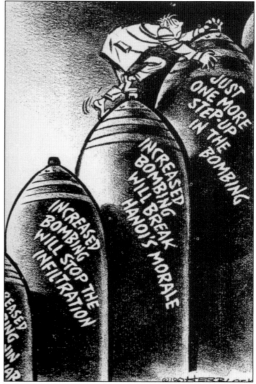

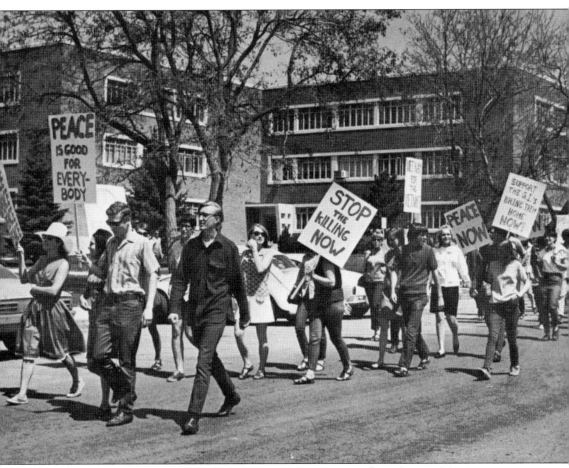

The 1960s were anything but calm. Students staged sit-ins, peace marches, and demonstrations, and boycotted classes to protest the US involvement in the Vietnam War. According to the *Idaho State Journal*, the Pickets were a tiny group of students and faculty members known collectively as radicals, and the Denounce was the first anti-war protest rally held at Idaho State University. This was just the start of a short history of student activism on the ISU campus. Since 1965, other protests have occurred, but most of them have been related to the Vietnam War, the largest of these being a peace march in 1967.

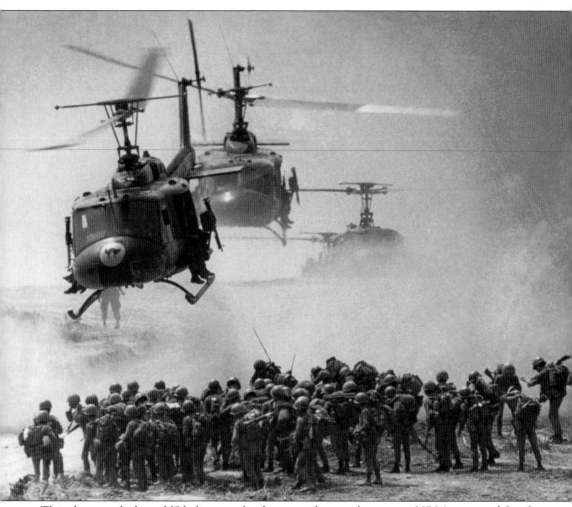

This photograph shows US helicopters landing to pick up and transport US Marines and South Vietnamese soldiers. In 1971, Val Wuthrich was drafted out of Montpelier, Idaho, and set off for South Vietnam. Participating in the Battle of Hamburger Hill was anything but an enjoyable experience. Dropped right at the base of the hill, there was little to no time for Wuthrich to find cover before the rounds started firing. Getting hit with shrapnel in the beginning of the battle, Wuthrich had to sit through the night for a medevac to get out. Three men in his squad died in combat that night. When recalling these memories, Wuthrich told the *Idaho State Journal*, "To this day some of those memories still give me chills and bring raw emotions to the surface." For many veterans who survived, their experiences in Vietnam led to a flood of terrible and difficult memories, and serious cases of post-traumatic stress disorder.

Six

ADVERTISEMENTS THROUGH THE YEARS

HOWARD BROS., and MACKIE FEED STORE

Wholesale and retail feeds, grains, flours, hays. breakfast goods. Everything is guaranteed to be first class.

SOUTH FIRST AVE.,
OPPOSITE POCATELLO MER. CO.
PHONE 51-BLACK

A typical feed store would have the basics of cooking products while providing a place to grab a quick bite to eat. Howard and Mackie provided these services with great quality in Pocatello. Being one of the first businesses to utilize telephone service, their phone number, like others of the time, included words as well as numbers.

Made in New York

BY the time this season's New York fashions have been copied in other cities, they have ceased to be stylish in New York. The only way to be sure you are wearing this season's style is to buy clothes designed in New York City and made by tailors who put in the making that workmanship which assures the retention of the style features. The Alfred Benjamin & Co. label gives this assurance absolutely.

Alfred Benjamin & Co. MAKERS. NEW YORK

Correct Clothes for Men

Exclusive Agent Here.

The Blyth & Fargo Co.

Pocatello, Idaho

Blyth & Fargo (above) was one of the biggest men's clothing departments in Pocatello at the beginning of the 20th century. This advertisement mentions that the clothing was made in New York, when the chain actually developed in the Northwest, with one of the first stores of the chain in Pocatello. During the 1900s, the field of medicine was developing at a rapid pace. Among the first remedies were ones for anything to do with lungs. The "grip" or "grippe" is now commonly known as influenza or the flu. Bromo Chemical Co. (left) was an innovator in medicine and was one of the only providers at the time. Most drugstores carried the company's products, and Bromo was one of the first companies to deliver drugs through the mail.

In a railroad town like Pocatello, liquor was a sought-after commodity. At the beginning of the 20th century, the beer industry was undergoing substantial changes. Improved methods of production and distribution meant that large breweries like Budweiser (right) became more dominant while the number of smaller breweries declined. However, the rise of mass distributors did not deter the Jos. Cohen Liquor Company, a small distributor in downtown Pocatello (below). This advertisement is notable for providing a three-digit telephone number.

Drink Budweiser Beer and

OLD FORT HALL
HAND MADE
KY. WHISKEY
POCATELLO, MER. CO.
SOLE DISTRIBUTORS

Jos. Cohen Liquor Co.

COME in and get a number on the beautiful premiums which we are giving away with every 25c purchase. See the beautiful display of premiums in our window.

PRICES WILL BE GIVEN AWAY MONDAY, APRIL 1st.

Jos. Cohen Liquor Co.

233 N. Main Phone 234

Pocatello was a place of prosperity during the 1900s, in large part because of the railroad traffic that would come in and out at all times of the day. The demand for retail banking services prompted Judge Drew Stanrod and D.L. Evans to open First National Bank (above, with all four employees listed). Stanrod, at various times a district judge and prominent attorney in Pocatello, held interests in as many as 10 banks. In 1902, he used his wealth to build the Stanrod Mansion, a beautiful chateauesque home that still sits on North Garfield Street in Pocatello. With trains coming in day and night, shops that were open 24 hours were essential. For anyone who had to leave town early or was up late working on some important project and needed food or coffee, Fred's (left) was the place to go.

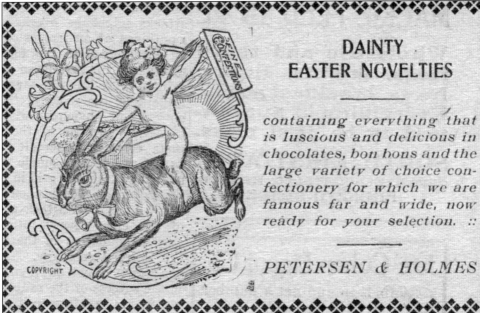
Everything was tough in the Wild West, except for kids riding on rabbits holding a massive box of chocolate (above). Even the toughest of men could not resist the urge of the daintiest of chocolates. With one of the first advertisements that had a very artistic drawing, Petersen & Holmes was ahead of its time. In sharp contrast, the Oregon Short Line Railroad did not really need to advertise other than listing times its trains were arriving and departing. If people needed to get somewhere at a certain time, this would be the best source to evaluate what train they needed to take.

MAKE A LITTLE
GO A LONG WAY

by doing your dealing in any of the lines we carry right in this store. The way we buy goods enables us to sell attractive articles at attractive prices. You, Mr. and Mrs. Customer, and your family, will treat yourselves well if we have the supplying of your wants. A steaming hot cup of our "Famous" coffee whits the appetite and makes any food taste good. Try a pound.

POCATELLO CASH GROCERY.

The Pocatello Cash Grocery (left) was known for the coffee provided by the employees at checkout time. Their service was also top notch, as they strived to foster the best experience for their customers. As noted in the ad, it was a cash-only store with no type of tab or credit system in place. Many of their items were at a lower price than their competitors, driving other local stores out of business. Below, the Senate Saloon was considered one of the highest-tier saloons in the city. The Senate Saloon was a "gentlemen's" area where only the finest of beverages would be sold along with the opportunity to play billiards.

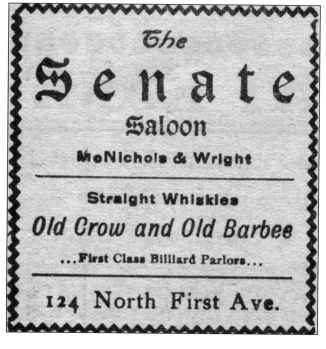

The
Senate
Saloon
McNichols & Wright

Straight Whiskies

Old Crow and Old Barbee

...First Class Billiard Parlors...

124 North First Ave.

During the earlier years of the *Pocatello Tribune*, the borders of printed advertisements were not always clearly delineated. In the ad clipping above, three businesses are represented. It shows the phone number of an unknown company, an ad for P. Hansen's grocery, and the Clinkenbeard School of Music. Indiscriminate readers calling 139-Z for a delivery of P. Hansen's Idanha butter could have been frustrated after calling the wrong number for a grocer who did not provide delivery services. At left, J.A. Folger's sold a variety of items, from coffee grounds to spices for foods. Folger became more associated with coffee than spices, but the brand name was instrumental in selling the product in cities throughout the West.

Spring's Favorite

tonic is the American Pilsener beer. It is invigorating, bracing and gives appetite when the Spring's first balmy days robs you of it, and is a grateful and a delicious beverage. By all means try American Pilsener beer for your Spring tonic, as well as a tonic all year 'round.

The 1907 advertisement above gives an airy feeling of wistfulness in the image and caption. The image reflects the delicate, flowery aroma of a Pilsner beer, while the 52-word caption (long by today's standards) describes the "invigorating" crisp bitterness of this classic beverage. The advertisement below also includes a very wordy caption with a "show off" kind of attitude. It introduces the pure food test. It shows 25 ounces for 25¢, a hard-to-forget price of the product.

Pure Food Assured

The National Pure Food Law has stopped the sale of all impure food products. No more need for worry on that score! It's now a question of efficiency and good value for your money.

KC BAKING POWDER

for years has stood every test for purity and wholesomeness.

Its *superior quality* shows in the delicious cakes and biscuit that K C is guaranteed to make.

The *price* is a saving of over half your baking powder money—

25 ounces for 25 cents.

If you have never tried K C, *do so now* under the following guarantee:

Your Grocer will sell you a can of K C on trial. Use it for your favorite cake. It will be lighter, tastier, more delicate,—or we pay him for the can. It will open your eyes. Try it quick. Don't delay. You are missing much.

JAQUES MANUFACTURING COMPANY, Chicago

Advertisements for Chesterfield cigarettes and all other cigarettes and cigars were extremely popular. The tobacco industry enjoyed promotion from official spokesmen like Ronald Reagan, Bob Hope, Bing Crosby, and later the Marlboro man. Even James Bond enjoys his Chesterfields in Ian Fleming's 1959 novel *Goldfinger*. Cigarettes were a standard part of the soldier's field rations during the two world wars, with Chesterfield being a large distributor.

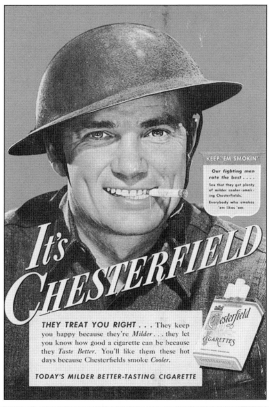

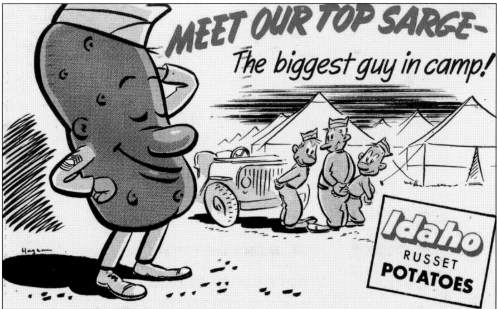

One of the most widely grown potatoes in North America, the russet potato is the most popular potato in the Western hemisphere. It was very commonly found in rations used by soldiers in the many wars of the 20th century. Their abundance in Idaho is a probable cause of Idaho being considered "the potato state" to many across the country.

Life can be CHARMING

... when you

Live Better

ELECTRICALLY

IDAHO ▼ POWER
A CITIZEN WHEREVER IT SERVES

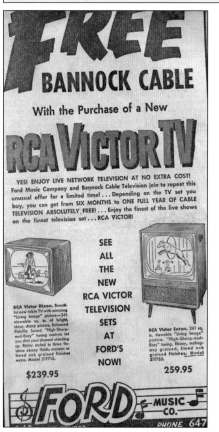

The ad above for Idaho Power was printed in the *Idaho State Journal* in 1958. This was a year of huge expansion for Idaho Power. Building the Brownlee, Oxbow, and Hells Canyon Dams as components of the Hells Canyon Complex, a 46,000-volt substation in Alameda, and a substation in American Falls kept the company extremely busy. Additional transmission and distribution lines were also installed at the Pocatello substation to support new irrigation pumps servicing the dry southeastern Idaho area. At left, Ford's Music was an important retailer in Pocatello's downtown on West Center Street. This 1957 advertisement touts free cable television as an alternative signal source for homes with poor reception.

The Pocatello Greenhouse & Garden Center (right) was a garden and craft center at the corner of Oak Street and Hyde Avenue. It opened in 1904 and remained in business for 112 years, closing in August 2016. Below is a clever advertisement for Blocks, one of the most upscale clothing retailers in Pocatello. Established by Nate Block, the business was sold to his son Sy Block in 1956 and expanded to a new location off Yellowstone Avenue near the original Halliwell Field. Blocks ultimately closed in 1974.

For fun and entertainment, Pocatello residents have enjoyed a fair number of options. The Eastern Idaho State Fair (left) began as a livestock show in 1902 and is held every September, 25 miles north of Pocatello. For a different kind of entertainment, the Green Triangle (or Green "T," below) was a lively establishment on the border between the cities of Pocatello and Chubbuck that began in the early 1920s. Before it closed in 2015, the Green Triangle hosted many VIP guests, including Pres. Harry Truman and Vice Pres. Hubert Humphrey, along with musical acts ranging from Willie Nelson to Alan Jackson to Waylon Jennings to the Platters.

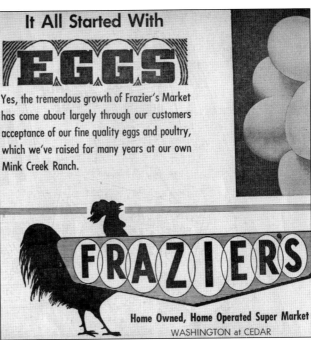

It All Started With

E.G.G.S

Yes, the tremendous growth of Frazier's Market has come about largely through our customers acceptance of our fine quality eggs and poultry, which we've raised for many years at our own Mink Creek Ranch.

FRAZIER'S

Home Owned, Home Operated Super Market
WASHINGTON at CEDAR

Two Pocatello institutions from the past were Frazier's grocery store and Grimm's Business College. Shown in the 1967 advertisement above, Frazier's was at the corner of Washington Avenue and Cedar Street in what was formerly the city of Alameda (which merged with Pocatello in 1962). Frazier's sold fresh eggs and fruit from its farm and orchards south of town, on the road to Mink Creek. Grimm's Business College (left) was in downtown Pocatello and specialized in stenographic training for individuals aspiring to secretarial positions. The demise of Grimm's was an indication of the declining importance of shorthand techniques in an era of handheld recording equipment.

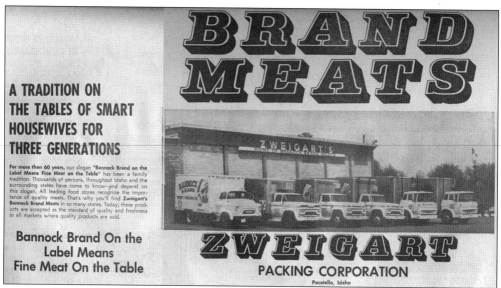

BRAND MEATS

A TRADITION ON THE TABLES OF SMART HOUSEWIVES FOR THREE GENERATIONS

For more than 60 years, our slogan "Bannock Brand on the Label Means Fine Meat on the Table" has been a family tradition. Thousands of persons, throughout Idaho and the surrounding states have come to know—and depend on this slogan. All leading food stores recognize the importance of quality meats. That's why you'll find **Zweigart's Bannock Brand Meats** in so many stores. Today, these products are accepted as the standard of quality and freshness in all markets where quality products are sold.

Bannock Brand On the Label Means Fine Meat On the Table

ZWEIGART

PACKING CORPORATION

Pocatello, Idaho

The 1967 advertisement above for Zweigart Packing Corporation appeared in the *Idaho State Journal*. The Zweigart brothers, Albert and Fred, were German immigrants who built a meatpacking plant south of Pocatello in 1905. They operated the packing plant and occupied a retail location in the 300 block of West Center Street (below). A massive fire destroyed the original meatpacking plant in 1945, but Zweigart built a new packing plant north of town in 1946 and continued to operate in Pocatello for decades.

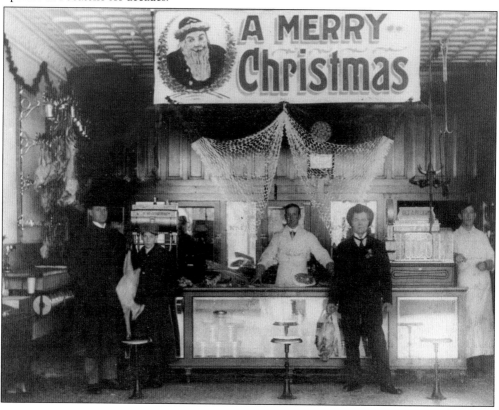

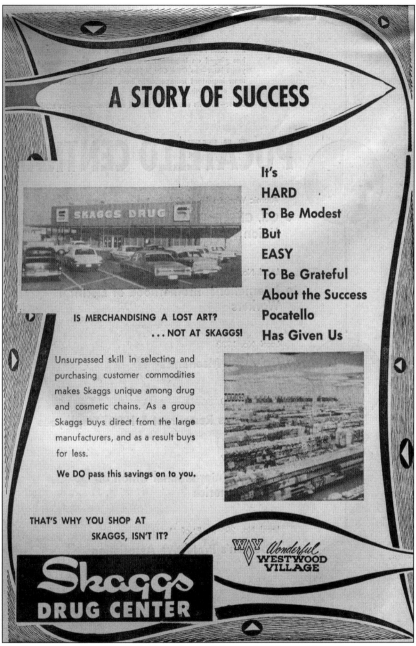

This 1967 advertisement in the *Idaho State Journal* shows the Skaggs Drug Center at its location in the Westwood Village shopping center on the west side of Pocatello. The original Skaggs drug store was founded by Samuel Skaggs 25 miles west of Pocatello in American Falls in 1915. Skaggs was unique for its time in that it operated on a cash-only (rather than credit) basis. With its location near the Union Pacific railroad tracks, Skaggs was able to order bulk goods in larger volumes and thus offer lower prices than its competitors. Skaggs ultimately merged into the Safeway grocery chain, and although the original Skaggs Drug Center is gone, the company retains its presence in Pocatello with the Albertsons grocery store on South Fifth Avenue (Albertsons effectively merged with Safeway in 2015).

Pocatello residents had multiple options for theater, both the movies and live. The Crest Theatres complex (left) was a prime location to watch the newest movies in Pocatello in 1967. Located two blocks from the Yellowstone Highway on Oak Street, the Crest was originally in the south end of the city of Alameda (which merged with Pocatello in 1962), where the Reel Theatres stand today and continue to serve the Pocatello community by showing second-run movies. Since ISU's beginnings as the Academy of Idaho, when plays were performed in Swanson's assembly hall, theater productions have been an important part of student and community life. With the completion of Frazier Hall in 1924, Theatre ISU (below) found a new home. Many productions took place in the approximately 800-seat auditorium, which has since been renamed the Bilyeu Theatre. In 2004, Theatre ISU moved again to the state-of-the-art Stephens Performing Arts Center near the top of the hill across from Bartz Field.

Theatre ISU To Present 'Marionettes'

Elaborate costumes with matching wigs and fanciful sets spark Idaho State University's production of "The Marionettes" which will play Thursday, Friday and Saturday in Frazier Auditorium.

The "modern comedy in a Harlequin style" is directed by Allen P. Blomquist, assistant professor of speech-drama and Theatre ISU business manager, and features a cast of 25 students.

Arriving in Pocatello in the late 1800s, Fargo's department stores were very involved and influential throughout the city. Being one of Pocatello's oldest mercantile establishments, many individuals in the area had unsurpassed loyalty to the store. Sponsoring sports teams, hosting events, and providing the community with continuous support, Fargo's finally met its demise in the late 1970s, when the Pine Ridge Mall made its debut.

James Cash Penney was a clerk for a Golden Rule store in Wyoming. In 1901, the owners of the chain, Guy Johnson and Tom Callahan, decided to give Penney the opportunity to run his own store nearby. This created the partnership that led to JCPenney. Within the first eight years, Idaho was home to six of the first 10 JCPenney stores, with two located in southeast Idaho.

ITEX, or Idaho Typewriter Exchange (left), was a popular chain of office supply stores located mostly in southern Idaho, including Pocatello. Established in 1918, the stores featured the popular Royal brand typewriter in addition to other office supplies.

Montgomery Ward supplied many Pocatellans with clothing, home goods, and furniture. These items came from mail-order catalogs or the retail location originally on Main Street. In 1966, the new location in Westwood Village became the largest in Idaho. The redesigned layout allowed for the display of 30 percent more merchandise than the previous location. In this 1967 ad in the *Idaho State Journal*, Ward's thanks its customers for their continued support after the move.

Two popular options for a quick lunch or dinner in Pocatello were the Red Steer drive-ins and Kentucky Fried Chicken. There were three Red Steer locations—on Hiline Road at the intersection of Alameda and Pocatello Roads, on North Main Street, and on South Fifth Avenue near the ISU campus. Owned by the Hawkins brothers, the Red Steers were three of many drive-ins in Pocatello during the 1950s, 1960s, and 1970s. Kentucky Fried Chicken, begun in Kentucky in 1930, had its first franchise location in 1952 in Salt Lake City. The brand was available in Pocatello at the Drumstick, at the corner of Oak Street and North Tenth Avenue. Later, it moved to its present location on Yellowstone Avenue.

Red Steer
FAMILY RESTAURANTS

Idaho's Finest Burger
"It's a Meal"
The **CENTENNIAL BURGER**
100% ¼ lb. Idaho Beef Patty, Bacon, Mushrooms, Swiss Cheese, Mustard, Special Sauce, Lettuce & Tomato On A Toasted Sesame Seed Bun.

It's on special in Celebration of Idaho's 100th Birthday!

Red Steer

1156 North Main 233-0491
1513 South 5th Avenue 233-0310

NO. 1
CHICKEN
SALESMAN

Colonel Harland Sanders sells more chicken than anybody in the whole wide world. More than a million Kentucky Fried Chicken dinners every single day! Now that's a lot of chicken. Makes you think it's pretty good? Take it from the Colonel . . . "it's finger lickin' good!" And it's ready to go from any of the more than 1,000 locations throughout the United States. Just pick it up and take it home. Today!

We fix Sunday dinner seven days a week

COLONEL SANDERS' RECIPE
Kentucky Fried Chicken.

Available Only At The ... DRUMSTICK

Phone 233-1676

Oak at 10th Ave.

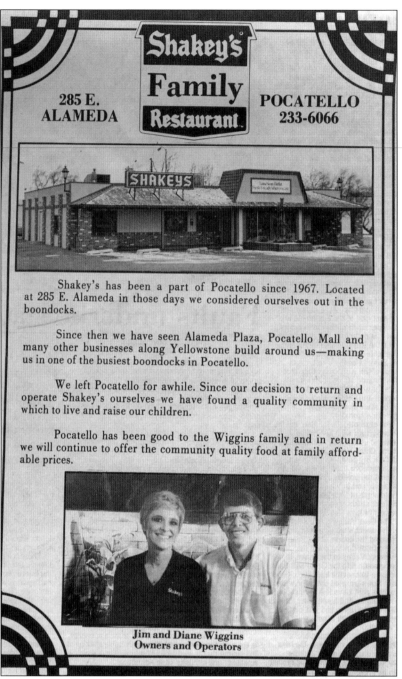

Shakey's Family Restaurant

285 E. ALAMEDA

POCATELLO 233-6066

Shakey's has been a part of Pocatello since 1967. Located at 285 E. Alameda in those days we considered ourselves out in the boondocks.

Since then we have seen Alameda Plaza, Pocatello Mall and many other businesses along Yellowstone build around us—making us in one of the busiest boondocks in Pocatello.

We left Pocatello for awhile. Since our decision to return and operate Shakey's ourselves we have found a quality community in which to live and raise our children.

Pocatello has been good to the Wiggins family and in return we will continue to offer the community quality food at family affordable prices.

Jim and Diane Wiggins
Owners and Operators

Shakey's Family Restaurant was a popular spot for pizza not only in Pocatello but at many locations across the United States. Originally founded in 1954 in Sacramento, California, the Pocatello restaurant was built in 1967. Located at 285 Alameda Avenue, the restaurant seemed to be on the outskirts of town, but later the Pocatello Mall and other businesses built nearby and made Shakey's feel much more centrally located. Since Shakey's was a franchise, many of the parlors had the same distinct building style. Live music was another hallmark of Shakey's, along with silent movies and, at the Pocatello location, ski movies to draw in a crowd.

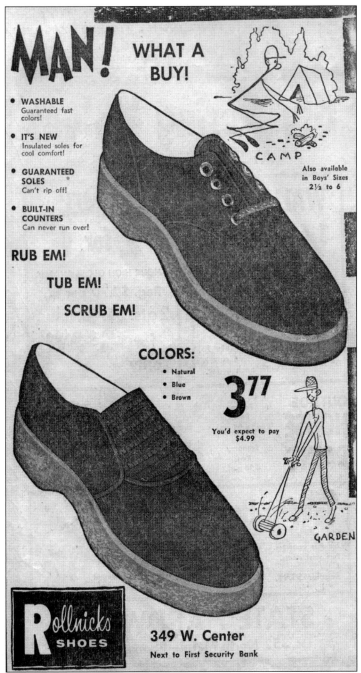

A number of shoe stores were in business in Pocatello in the 1950s and 1960s, including Rollnick's Shoes at West Center Street downtown. In the late 1950s, Rollnick's held a "Baby of the Week" photograph contest. Customers who purchased a pair of children's shoes received a gift certificate to have the child's picture taken by a local photographer at Champion Studio. That photograph could then be entered in the contest, and the winners were published in the newspaper. There were other popular shoe stores in the area as well. Some of the names included Hudson's, Terrell's, and Brown's.

IF YOU DO TAKE A DRINK DO INSIST ON THE BEST

THERE IS SATISFACTION

in knowing that you can get the BEST in the liquor and cigar line AT THE SAME PRICE by picking the RIGHT PLACE to buy it.

The Q. P. and Board of Trade

sell nothing but the finest in the world at the usual established prices.

The Q. P. Corner Cleveland Ave. and Center St.
Board of Trade, Corner First Ave and Center St.

W. E. TRAPP & CO.

This 1907 advertisement touts the virtues of the drinking establishments owned by W.E. Trapp & Company in Pocatello. Trapp was strategic in locating saloons along the busy Center Street corridor, on both the west (at the intersection of Cleveland, now Main Street) and east (at the intersection of First Avenue) sides of the railroad tracks. In 1926, W.E. Trapp passed away. He was remembered for serving on the city council and purchasing several properties to develop Pocatello's downtown. His own two-story home was at 340 South Garfield Avenue, in what is now Old Town Pocatello.

Seven

POCATELLO'S PAST MEETS PRESENT

As this photograph demonstrates, what is now Riverside Golf Course on the south side of Pocatello looked a lot different in the 1880s than it does today. Theodore F. Turner, a state senator from Pocatello, gifted a 160-acre farm to what is now Idaho State University in 1909 for the school's agriculture program. Even though the land is now used for golf rather than growing food, it is easy to see that the clubhouse was once a barn. (Courtesy of BCHM.)

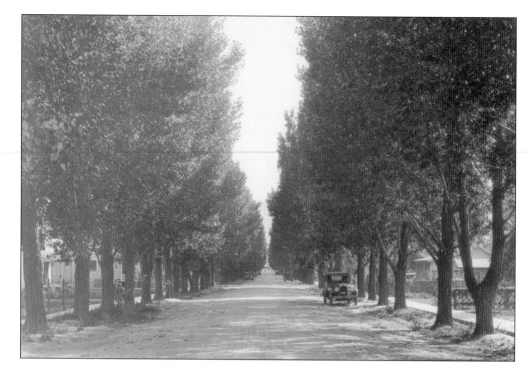

The photograph above from the early 1920s shows the tree-lined residential areas along Alameda Road in Pocatello, a definite contrast with the commercial district it has become (below). The town of Alameda was originally its own separate municipality north of Pocatello and well-situated on the Yellowstone Highway (now US 91), one of the first designated highways in Idaho. When Alameda voted to merge with Pocatello in 1962, it briefly made Pocatello the largest city in Idaho. (Above, courtesy of BCHM; below, courtesy of Brooke Barber.)

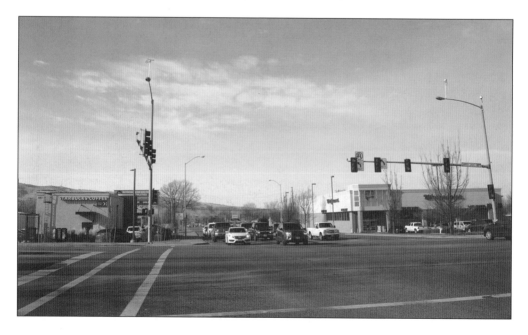

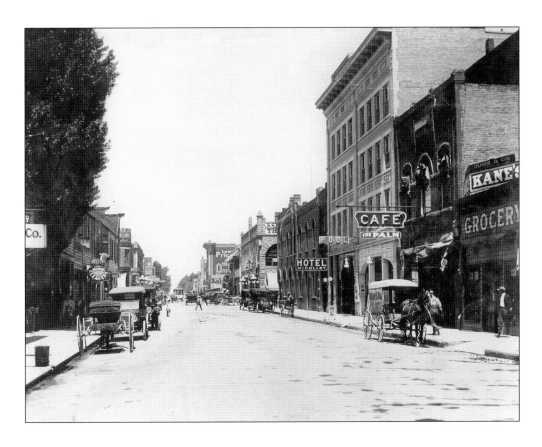

The photograph above, taken in 1913, shows the view looking north down Main Street in Pocatello. Main Street was originally named Cleveland Avenue in honor of US president Grover Cleveland, whose two terms in office coincided with Pocatello's early development. Main Street became the primary commercial center in downtown Pocatello, and many of the original buildings have been preserved (below). (Above, courtesy of BCHM; below, courtesy of Brooke Barber.)

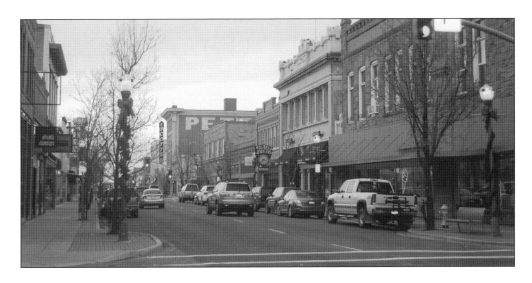

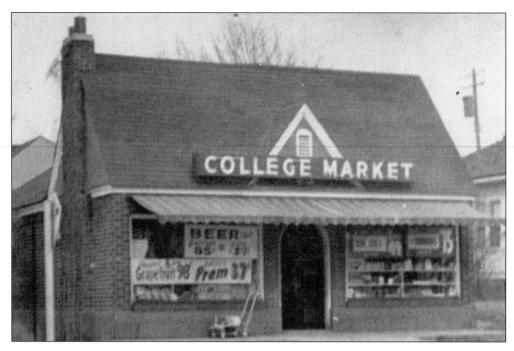

Although many buildings have changed in Pocatello over the years, it is reassuring to see that others have stayed much the same. The College Market was a grocery store on South Eighth Avenue that primarily served the students of Idaho State University and the residents of the university neighborhood north of campus. It was reopened in 2013 as a coffee shop. Although the menu has changed from 1957 (above), the exterior today (below) looks very similar 50 years later. (Below, courtesy of Brooke Barber.)

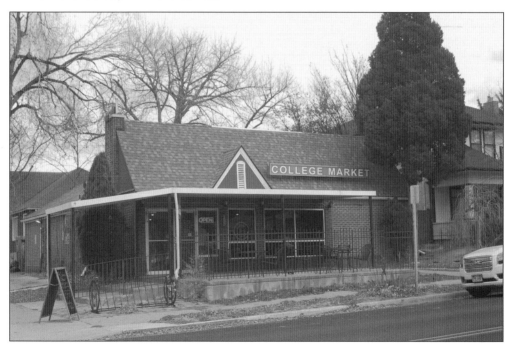

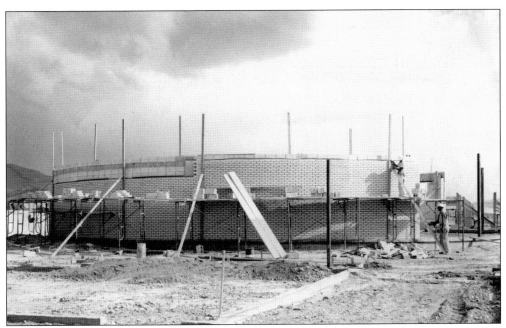

For 70 years, Pocatello High School was the only high school in the city. However, as Pocatello's population grew rapidly in the decade following World War II, plans were made to build a second high school to alleviate overcrowding. Highland High School was opened in 1963 on the northeast bench overlooking the city, over 200 feet in elevation above Pocatello High School, which is located downtown in the valley along the Portneuf River. Highland's distinctive shape (above) was reportedly modeled on railroad roundhouses and paid tribute to the legacy of the railroad in Pocatello. Although it was in a fairly remote part of town when it opened, the city has grown up around Highland High School. (Below, courtesy of Brooke Barber.)

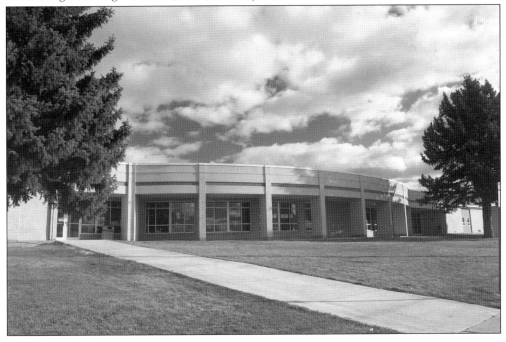

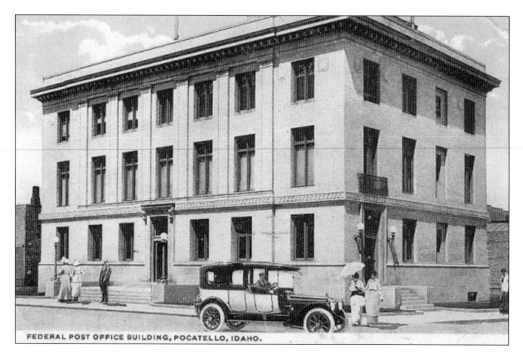

FEDERAL POST OFFICE BUILDING, POCATELLO, IDAHO.

The Federal Building, shown in the postcard above from the late 1910s, was built in 1916 at 150 South Arthur Avenue in Pocatello. This is one of the few buildings in Pocatello's Old Town that was built originally as a government facility—in this case, as a post office and federal office building. Today, the building hosts private businesses and a vocal studio. (Below, courtesy of Brooke Barber.)

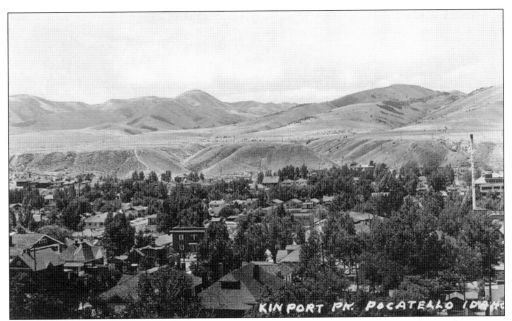

The photograph above looks toward the west bench of Pocatello in the early 1940s, with Kinport Peak rising in the distance. Kinport Peak was named after the Kinport brothers, Dave and Harry, who both came to Pocatello in the 1880s to work for the Oregon Short Line Railroad. Although Dave was renowned as an avid hiker, it was Harry who made the greatest mark on the city. Harry Kinport ran an opera house, the Auditorium Theatre, and promoted the arts scene in Pocatello even when a lack of citizen support meant that he had to cover losses out of his own pocket. Harry Kinport was so well liked that Mayor J.B. Bistline canceled work for city employees so that they could attend his funeral in 1912. Kinport Peak still presides over the west bench of Pocatello and serves as a recreation hotspot overlooking the City Creek trail system. (Below, courtesy of Brooke Barber.)

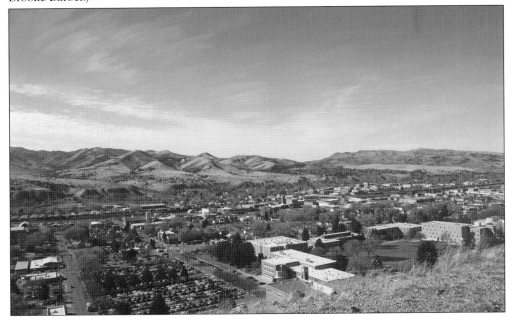

McHan's Funeral Home (above) stood west of South Arthur Avenue in Old Town Pocatello, near West Lewis Street. The pillars were removed in 1966 when the building was relocated, and they were donated by the Jack Henderson family to Idaho State University. After sitting in storage for several years, the pillars were installed at the top of Red Hill, overlooking campus, in 1970. (Below, courtesy of Brooke Barber.)

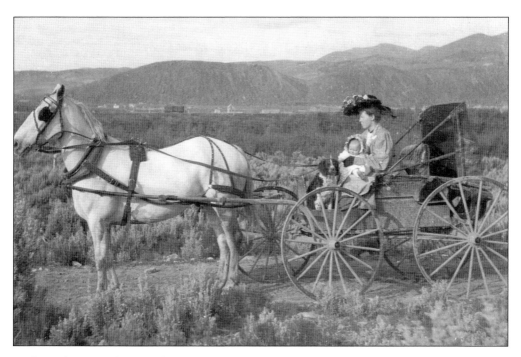

In the early 1900s photograph above, a woman identified as Johanna Wood sits with her infant and a family dog in a carriage on a dirt trail through sagebrush near what is now South Grant Avenue in Pocatello. In the distance, looking east, is Red Hill and the Academy of Idaho (now Idaho State University) campus. This location is now Centennial Park (below), which was opened on the southwest end of Pocatello in 1990 to celebrate the state of Idaho's centennial. (Below, courtesy of Brooke Barber.)

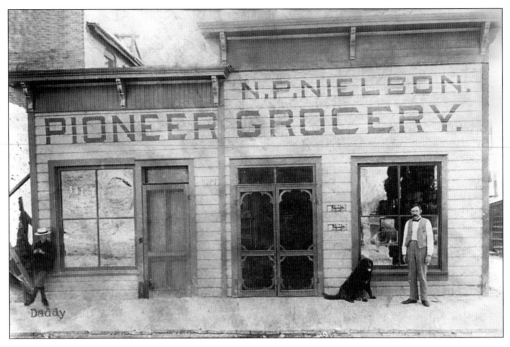

N.P. Nielson, the founder of Nielson's Pioneer Grocery in Pocatello (above), emigrated with his family from Denmark shortly after the American Civil War. Prior to opening one of the first grocery stores (or "houses") in Pocatello in 1888, Nielson served as the young town's constable. He would also serve as the treasurer of Pocatello's home county, Bannock County. Nielson's grocery store once stood in the 100 block of North Cleveland Avenue, which is now Main Street (below). (Below, courtesy of Brooke Barber.)

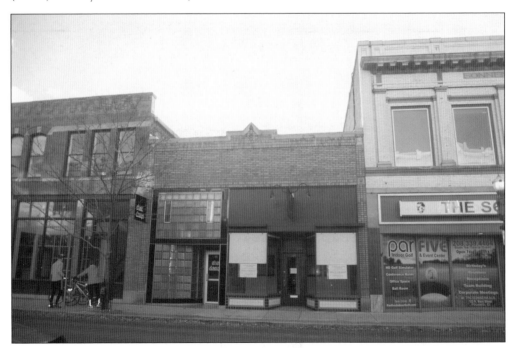

Cotant Truck Lines, begun by J.O. Cotant, was incorporated in 1933 and headquartered in Pocatello. The line served Idaho, Utah, Nevada, and California, with its major business being hauling cheese for Kraft between Pocatello and San Francisco. In 1944, the company was purchased by Garrett Freightlines. Cotant was located at the corner of South Second Avenue and Benton Street. When J.O. Cotant sold the business, he sold the building to the Idaho Power Company, which still uses that location. (Below, courtesy of Brooke Barber.)

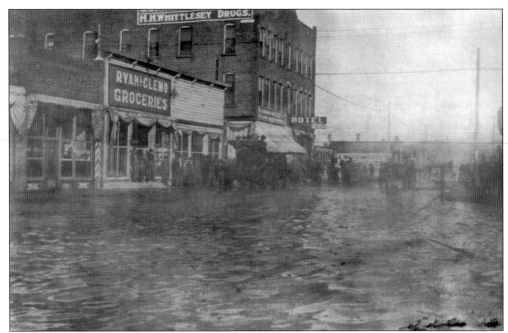

The photograph above from 1911 shows massive flooding along the 300 block of East Center Street. The tall brick building housed Horace H. Whittlesey's drugstore and was across the street from the Auditorium Theater opera house. Whittlesey eventually sold his Pocatello location and moved to Twin Falls, Idaho. His daughter, Byra Louise, met and married Jack Hemingway, the son of Ernest Hemingway, who had a residence in Sun Valley, Idaho. Thus, in yet another Hollywood connection to Pocatello, Horace Whittlesey was Mariel Hemingway's (less famous) grandfather. E-Fresh and Pocatello Co-Op are two of the restaurants that occupy the district today (below). (Below, courtesy of Brooke Barber.)

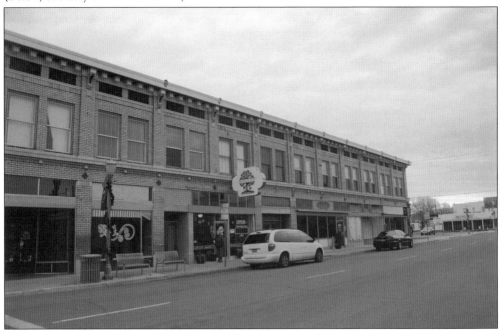

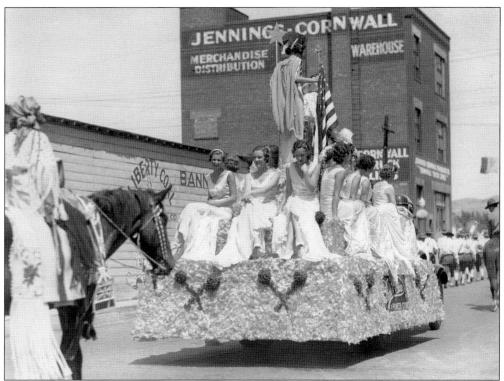

A float for the People's Store, a department and variety store in downtown Pocatello, proceeds down First Avenue in a Fourth of July parade in the 1940s. The Jennings-Cornwall building rises in the background. According to an Associated Press story, following the passage of the 21st Amendment that repealed Prohibition, one-third of the first legal shipment of liquor for Idaho's package stores in nearly 17 years was unloaded in Pocatello at the Jennings-Cornwall warehouse (Boise and Lewiston were the other destinations of the shipment). Both Jennings-Cornwall and Bannock Lumber & Coal (light-colored building at left) are now gone (below). (Above, courtesy of BCHM; below, courtesy of Brooke Barber.)

Although most people think that the long-standing brick buildings of Pocatello are centered in Old Town, the Martin Spring Works building (above) is well to the north of Center Street. A supplier of coil springs for cars and trucks and a provider of specialty welding, Martin Spring Works has largely retained its appearance and character (below). The building stands at 944 North Main Street, across the intersection of North Main and West Custer Streets from the Coca-Cola bottling plant. (Below, courtesy of Brooke Barber.)

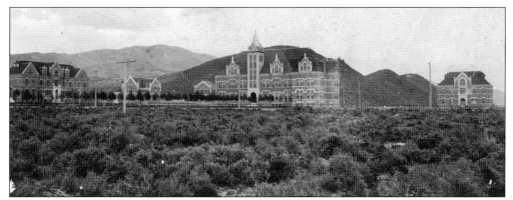

The 1906 photograph above shows Swanson Hall as seen from what is now Fifth Avenue (with Red Hill in the immediate background). Swanson Hall was the first building constructed for the Academy of Idaho (later renamed Idaho State University). The building served as administration offices for the institution and classroom space for liberal arts. Though the building was torn down in 1973, the arch remains standing and is now the location for one of the university's most beloved campus traditions, called "March through the Arch." Each fall with ISU's newest Bengals and each spring with graduating seniors, hundreds of students walk through the arch, symbolizing the beginning or the culmination of their academic journey. (Below, courtesy of Brooke Barber.)

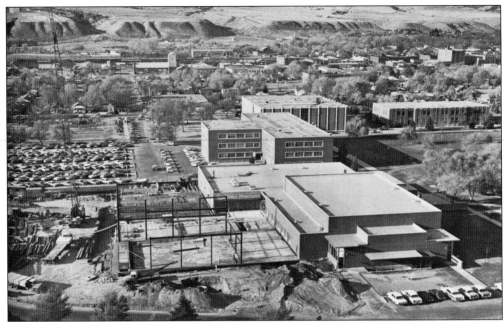

The photograph above shows the Pond Student Union under construction in the mid-1960s. Completed in 1966, the building was named to honor the legacy of Earl Pond, longtime Idaho State University student life staff member and lifetime supporter of the university. Pond was particularly instrumental in bringing outdoor adventure opportunities to ISU students and advocated for the formation of the Early Learning Center childcare center. Later construction expanded the building's available student services, and today (below), the Pond Student Union is complete with a movie theater, bowling alley, food court, ballroom for special events, post office, barbershop, outdoor recreation center, ISU Credit Union, and copy center. The building is also the home for the offices of the Division of Student Affairs. (Below, courtesy of Brooke Barber.)

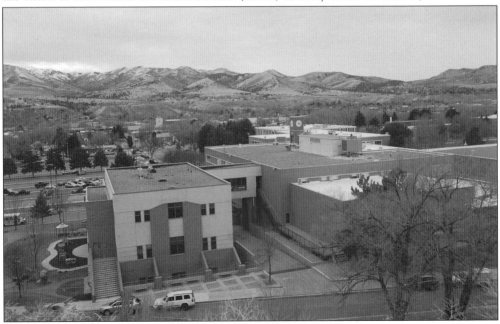

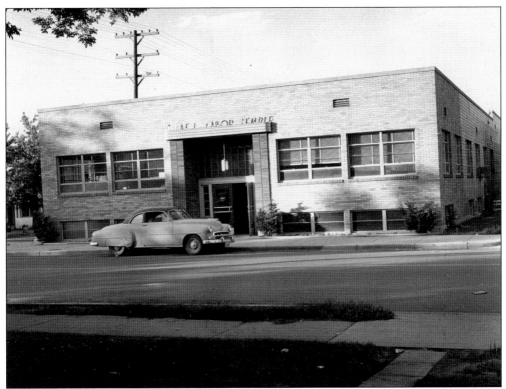

The American Federation of Labor (AFL) Labor Temple (above) was built in 1915 at 456 North Arthur Avenue. The AFL played a prominent role as a craft union in a railroad town like Pocatello, whose history of unionization began in the 19th century. The building still stands (below), about two blocks north of Pocatello High School. (Below, courtesy of Brooke Barber.)

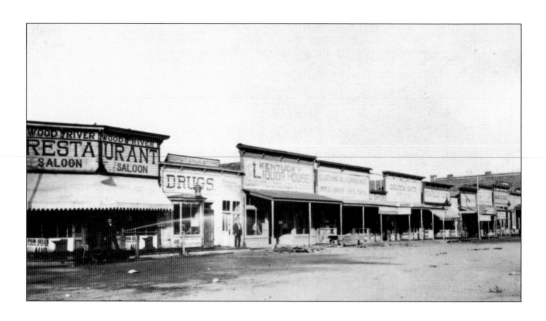

The original commercial district in Pocatello consisted of a series of rickety wooden buildings along Front Street (now First Avenue) on the east side of the railroad tracks. The 1892 photograph above shows the prominent businesses in a rowdy pioneer railroad town: saloons, drugstores, and a "liquor house." It was not until 1892 that the first commercial buildings were erected in the eventual downtown area west of the railroad tracks. As the east side wooden buildings burned down or were demolished, South First Avenue reinvented itself as a warehouse and commercial district with handsome brick buildings (below), many of which are still standing today. (Below, courtesy of Brooke Barber.)

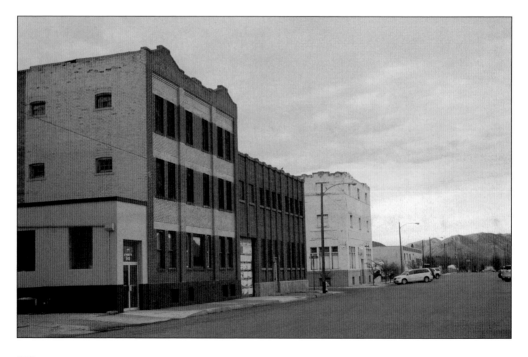

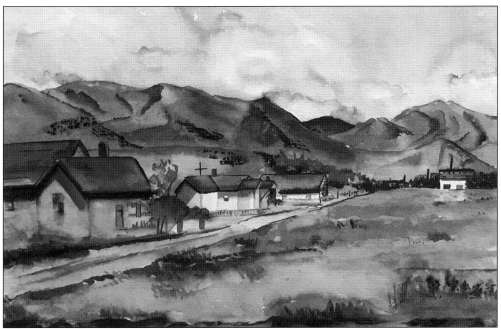

The corner of Oak and Pocatello (Yellowstone) Avenues was painted in watercolor in 1943 by Lucile Brokaw, cousin of journalist Tom Brokaw. The artist was staying as a guest of the Covey's North America Motor Lodge while her husband was stationed at the Army air base west of the city. St. Anthony's Hospital on Eighth Avenue can be seen at right center. To the right of St. Anthony's is the chimney of Franklin Junior High School, followed by an auto shop. The southwest corner between Covey's and the auto shop would become Halliwell Park Stadium, the home of the Pocatello Cardinals baseball team. Camelback Mountain is on the left, and the mountains of the Portneuf Gap are to the right. The same view today, as seen below, includes local news station KPVI. (Above, courtesy of MPL; below, courtesy of Brooke Barber.)

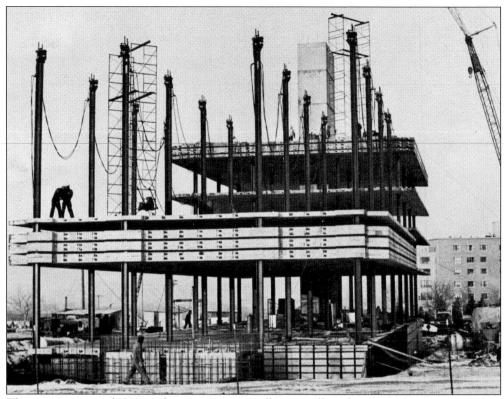

The construction of ISU's eight-story Turner Hall, originally a dormitory for women, and its twin Garrison Hall, originally a dormitory for men, was to help alleviate the university housing shortage. In order to build the complex, construction crews had to pour cement at ground level and hydraulically raise each floor. (Below, courtesy of Brooke Barber.)

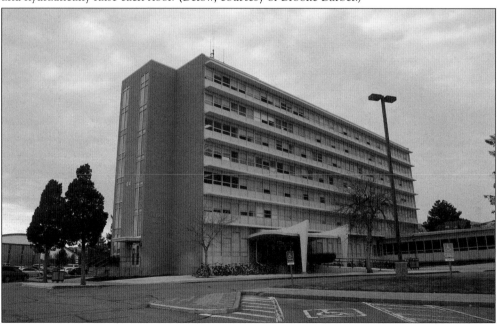

The 1960s photograph above shows students painting the iconic "I" on Red Hill. The tradition of a letter on Red Hill began in 1916, when students placed a "T" for Idaho Technical Institute. The transition to the letter I occurred in 1927, when the institution became known as the Southern Branch of the University of Idaho. Through the years, students and campus organizations such as the ISU Ambassadors took turns repainting the I. It was removed from the hill in 2014 due to safety concerns for those using the trails below Red Hill, but it is rumored to be making a (more sustainable) comeback soon. (Below, courtesy of Brooke Barber.)

This photograph shows the same view of Pocatello's downtown (now Old Town) as the cover of this book. The view looks west from the railroad tracks, with Main Street as the first intersection, followed by Arthur Avenue a block away. Whereas the 1913 photograph was taken from a viaduct that crossed above the train tracks, this photograph was taken above the tunnel by which the Center Street underpass now crosses beneath the train tracks. Notice how many of Pocatello's original downtown buildings along Center Street still stand today. (Courtesy of Brooke Barber.)

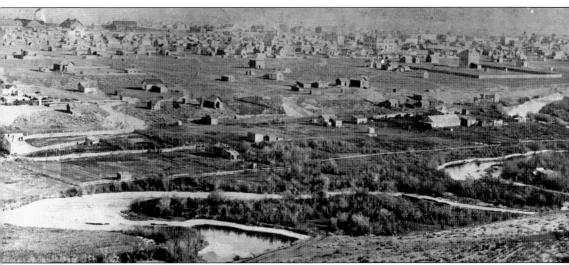

The book concludes with one of its oldest photographs, an image of the earliest dwellings in Pocatello Junction along the Portneuf River from the early 1880s. Looking back, it is remarkable that fewer than 140 years have passed since Pocatello consisted of little more than a brief stop on the railroad. We hope you have enjoyed this trip through the history of this remarkable community, nestled at the gateway to the Rocky Mountains. (Courtesy of BCHM.)

DISCOVER THOUSANDS OF LOCAL HISTORY BOOKS
FEATURING MILLIONS OF VINTAGE IMAGES

Arcadia Publishing, the leading local history publisher in the United States, is committed to making history accessible and meaningful through publishing books that celebrate and preserve the heritage of America's people and places.

Find more books like this at
www.arcadiapublishing.com

Search for your hometown history, your old stomping grounds, and even your favorite sports team.

Consistent with our mission to preserve history on a local level, this book was printed in South Carolina on American-made paper and manufactured entirely in the United States. Products carrying the accredited Forest Stewardship Council (FSC) label are printed on 100 percent FSC-certified paper.

MADE IN THE USA